# Anatomy
## for Artists

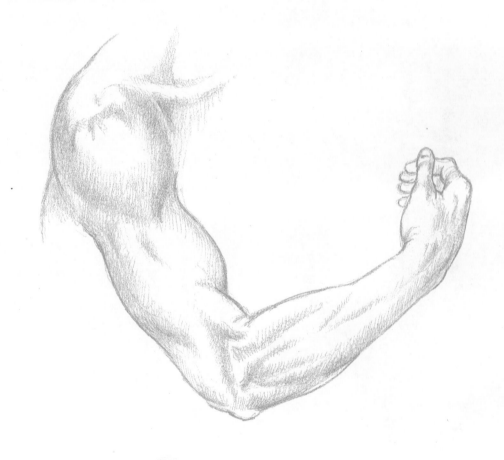

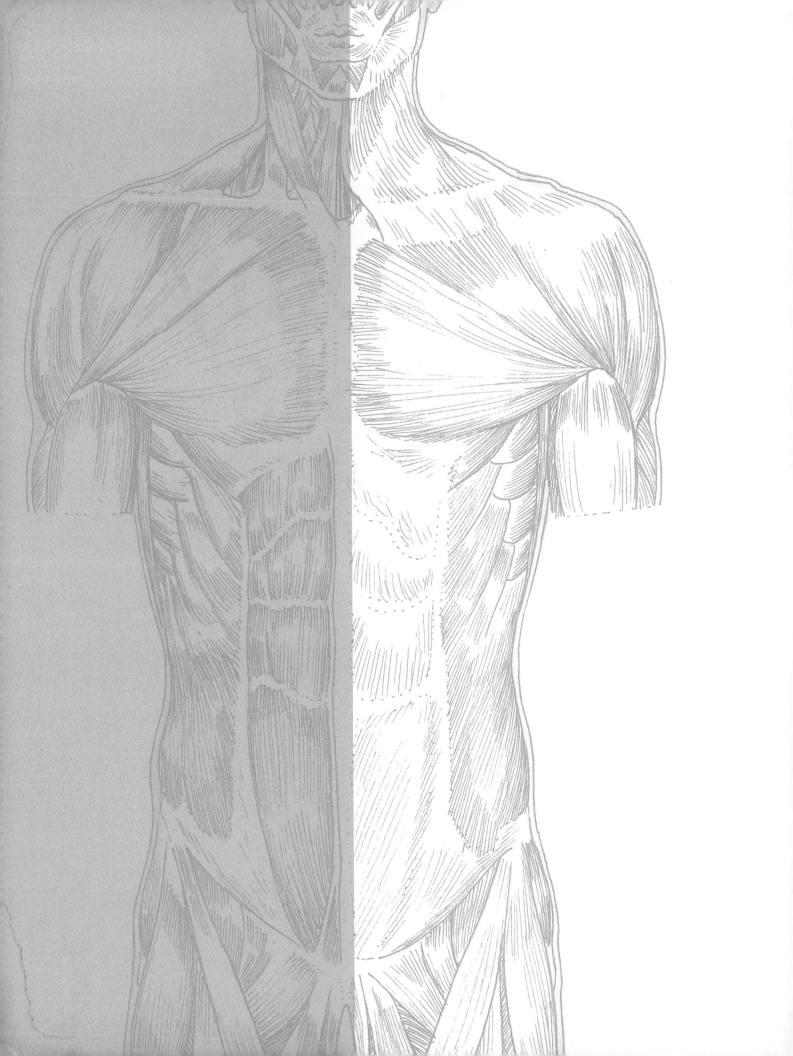

BARRINGTON BARBER

# Anatomy for Artists

## A Complete Guide to Drawing the Human Body

ARCTURUS

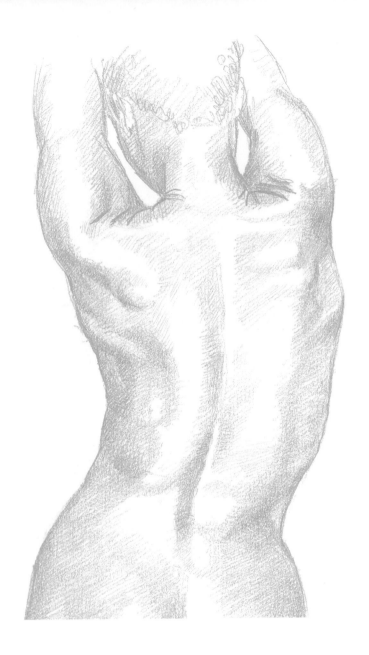

This edition published in 2016 by Arcturus Publishing Limited
26/27 Bickels Yard, 151–153 Bermondsey Street,
London SE1 3HA

ISBN: 978-1-78404-470-1
AD004403UK

Printed in China

# Contents

# Introduction

Anatomy books are essential for figure artists, but many are published for medical purposes and tend to give too much information. For example, the inner organs of the body are interesting to know about, but not relevant for drawing. What is important for the artist or art student to learn is the structure of the human form, based on the skeleton and the musculature. There have been a number of good and useful books on this subject. Some are a little out of date, not so much in the information they give, but in the way it is presented. Other well-produced contemporary books are mainly photographic.

My task here has been to produce a comprehensive anatomy book which has all the information necessary for an artist, using drawings and diagrams presented in an easy-to-follow format; and I also wanted to put into it everything I have found useful in my own drawing practices.

Firstly in this book I deal with the full figure, followed by chapters on the anatomy of the major parts of the body. Each section shows the skeleton from different viewpoints, then the muscles on top of the bone structure, and finally the surface form of the human body.

Of course, not all human bodies are perfectly formed and proportions differ from person to person. Throughout the book I have used well-proportioned, fairly athletic figures. This means that you will become acquainted with the shapes of the muscles at their best, although you will probably draw many people who do not have such well-toned bodies as these.

Throughout the book I examine each part of the body in detail, concentrating in particular on musculature

and how the body moves. Each area of detailed analysis may sometimes repeat what has been shown in previous chapters: this is necessary because some muscles overlie others and this, to a certain extent, changes their shape on the surface. So don't be surprised to see the same names cropping up from time to time, and it does make them easier to remember.

In the technical introduction at the start of the book you will find an explanation of descriptive terms used in medical circles, followed by a detailed list of Latin terminology. This is worth reading, because understanding anatomical terms will help you follow the annotations in the book. It may take a little time to remember all the names you need, but after regular use of these terms you will usually remember enough to describe what you are looking at.

I have omitted any description of the brain, heart, lungs and other viscera because these items are housed within the cranium, the ribcage and the pelvis, and it is the bony parts of the body which dictate the surface shape for figure-drawing purposes. I have also left out details of the male genitalia, because the differences in size and shape are too variable.

Throughout history, artists have looked at our bodies and shown their beauty, force and distortions. I have used the best possible references to draw these pictures, including my own life studies, but have not drawn from dissected corpses as Michelangelo or Leonardo da Vinci did. Artists have contributed a lot to the study of anatomy, both for artistic and medical purposes. In drawing, the practising artist wants to capture the form of this complex bodily machinery, but before doing so he or she needs to know how it works.

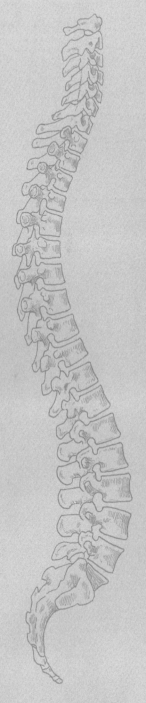

# Technical
# Introduction

*This section is intended to give you some initial detail about the human anatomy before starting to draw. I have described the properties of bones, muscles, tendons, cartilage, skin, fat and joints, and shown diagrams of the different types of joints and muscles. There is also an introduction to anatomical terminology: you will find this useful as certain terms are used throughout the book.*

## BONES

The skeleton is the solid framework of the body, partly supporting and partly protective. The shape of the skeleton can vary widely. It affects the build of a person and determines whether they have masses of muscle and fat or not.

Bones are living tissue supplied by blood and nerves. They can become weaker and thinner with malnutrition and lack of use or heavier and stronger when having to support more weight. They are soft and pliable in the embryo, and only become what we would consider hard and bone-like by the twenty-fifth year of life.

Humans have 206 bones, but it is possible to be born with some bones missing or even extra ones, and a few bones fuse together with age. We each have a skull, ribcage, pelvis and vertebral column, as well as arm, hand, leg and foot bones. Most bones are symmetrical. The bones of the limbs are cylindrical, thickening towards the ends. The projecting part of a bone is referred to as a **process** or an **eminence.**

Highly mobile areas of the body, such as the wrists, consist of numerous small bones. Other bones, like the scapula (shoulder blade) can move in all directions, controlled by the muscles around them.

The bones of the cranium (skull) differ from all others. They grow from separate plates into one fused vault to house the brain. The mandible (jawbone) is the only movable bone in the head.

The long bones of the arms and legs act like levers, while the flat bones of the skull, the cage-like bones of the ribs and the basin shape of the pelvis protect the more vulnerable organs such as the brain, heart, lungs, liver and the abdominal viscera.

## MUSCLES

The combination of bones, muscles and tendons allows both strong, broad movements and delicate, precise ones. Muscles perform our actions by contracting or relaxing. There are long muscles on the limbs and broader muscles on the trunk. The more fixed end of the muscle is called the **head** or **origin**, and the other end – usually farthest from the spine – is the **insertion**. There are powerful, thick muscles, like the biceps and the ring-shaped muscles (sphincters) surrounding the openings of the body, such as the eye, mouth and anus. Certain muscles grow together and have two, three or four heads and insertions. Combined muscles also have parts originating in different places. The fleshy part of a muscle is called the **meat** and the fibrous part the **tendon** or **aponeurosis** (see below).

Striated (voluntary) muscles operate under our conscious control. The 640 voluntary muscles account for up to 50 per cent of the body's weight and form the red flesh. Organized in groups and arranged in several layers, these muscles give the body its familiar form. The drawings below show the various types of striated muscles, with the tendons at each end. Note the distinctive shape of the sphincter muscle on the far right. Smooth (involuntary) muscles are confined to the walls of hollow organs, such as intestines and blood vessels. They function beyond our conscious control.

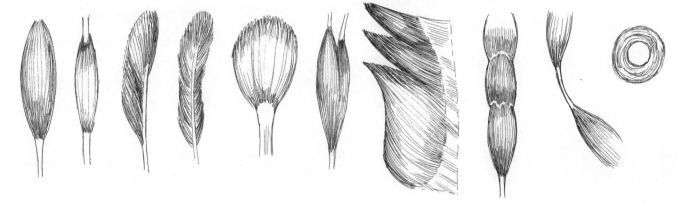

Cardiac (heart) muscles are both striated and involuntary, with a cell structure that ensures synchronic contraction.

## TENDONS

The tendons are fibrous structures that attach the ends of the muscles to the bones at protruding points called **tubercles** and **tuberosities**. Some muscles are divided by intervening tendons (see illustration above, second from right). Tendons may be round and cord-like or flat and band-like, consisting of strong tensile fibres arranged lengthwise. They are inextensible, allowing the muscles to pull hard against them. Many are longer than the muscles they serve, such as in the forearm.

### APONEUROSES

These are broad, flat, sheet-like tendons, a continuation of broad, flat muscles that either attach to the bone or continue into the **fascia**.

### TENDINOUS ARCHES

Fibrous bands connected with the fasciae of muscles.

## FASCIAE

Fibrous laminae of various thicknesses, occurring in all parts of the body, enveloping all muscles, blood vessels, nerves, joints, organs and glands. They prevent friction between moving muscles.

## LIGAMENTS

Fibrous, elastic bands situated at joints where articulated bones connect, or stretched between two immobile bones.

## CARTILAGE

Cartilage is connective tissue composed of collagen (a protein). Fibrous cartilage forms the symphysis pubis (the joint between the pubic bones) and invertebral discs. Elastic cartilage gives shape to the outer flap of the ear. Hyaline cartilage – the most common form – covers the **articular** surface of bones (the ends near the joints); forms the rings of the trachea (windpipe) and the **bronchi** (airways) of the lungs; and gives shape to the lower ribcage and nose.

## SKIN

A tough, self-replenishing membrane about 2 mm thick, which defines the boundary between the internal and external environments. Human skin is thickest on the upper back, soles of the feet and palms of the hand; it is thinnest on the eyelids. Not only the body's largest sense organ, the skin also protects the body from abrasions, fluid loss and the penetration of harmful substances. And it regulates body temperature, through perspiration and the cooling effect of surface veins.

### *EPIDERMIS*

The skin's top layer with the dermis beneath, a thicker layer of loose connective tissue. Beneath this is the hyperdermis, a fine layer of white connective fatty tissue also called the **superficial fascia.**

## FAT

Fat is the body's energy reserve. Its layers soften the contours of the skeletal-muscular frame. Fat is primarily stored around the buttocks, navel, hips, inner and outer thighs, front and back of knees, beneath the nipples, on the back of the arms, in the cheeks and below the jaw.

## JOINTS

Joints form the connections between bones. In fibrous joints, such as sutures in the skull, there is no appreciable movement. There is limited movement in the cartilaginous joints. The most mobile are the synovial joints such as the knees, where the bones are not fixed.

The principal movements of the joints are **flexion**, which means bending to a more acute angle; **extension**, or straightening; **adduction**, which means moving towards the body's midline; **abduction**, moving away from the midline; and **medial** and **lateral rotation** (turning towards and away from the midline).

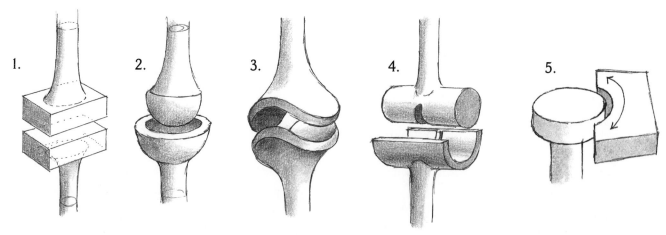

### 1. PLANE JOINT

Formed by flat or slightly curved surfaces, with little movement, such as the instep.

### 2. BALL AND SOCKET JOINT

The spherical edge of one bone moves in a spherical excavation of another, like the hip joint.

### 3. SADDLE OR BIAXIAL JOINT

Allows limited movement in two directions at right angles to each other, like the thumb.

### 4. HINGE JOINT

Bending and straightening movement is possible on one plane only, such as in the knee, the elbow and the finger.

### 5. PIVOT JOINT

One bone moves around another on its own axis, such as the radius and the ulna.

## UNDERSTANDING ANATOMICAL TERMINOLOGY

To those who have no knowledge of Latin, the Latin names of the muscles and bones may be rather off-putting and hard to grasp. However, once you understand that, for example, an extensor is a muscle involved in the process of extension, that **brevis** is Latin for 'short' and that **pollicis** means 'of the thumb', the position, attachment and function of the **extensor pollicis brevis** muscle become much easier to remember.

Even English anatomical vocabulary may not be familiar to everyone who sets out to draw the human body. For this reason, the main technical terms used in this book, both English and Latin, are explained here.

## Some technical terms in English

| | | | |
|---|---|---|---|
| DEEP | far from the body surface | ANTERIOR | relating to the front surface or part |
| SUPERFICIAL | near to the body surface | POSTERIOR | relating to the back surface or part |
| INFERIOR | lower | LATERAL | farther from the inner line of the body |
| SUPERIOR | upper | | |

| | | | |
|---|---|---|---|
| MEDIAL | of or closer to the median line down the centre of the body | DORSAL | of the back; of the back of the hand or top of the foot |
| DISTAL | farther from the point of attachment to the trunk | FRONTAL | of the forehead |
| | | HYPOTHENAR | of the mound of muscle on the little-finger side of the palm |
| PROXIMAL | nearer to the point of attachment to the trunk | LUMBAR | of the loins |
| PRONE | (of the arm or hand) with the palm facing down | MENTAL | of the chin |
| | | NUCHAL | of the nape of the neck |
| SUPINE | (of the arm or hand) with the palm facing up | OCCIPITAL | of the back of the head |
| | | ORBITAL | of the area around the eye |
| RADIAL | on the thumb side of the arm or hand | PALATINE | of the roof of the mouth |
| | | PALMAR | of the palm of the hand |
| ULNAR | on the little finger side of the arm or hand | PLANTAR | of the sole of the foot |
| | | SUPRAORBITAL | of the area above the eye |
| FIBULAR | on the little toe side of leg or foot | TEMPORAL | of the temple |
| TIBIAL | on the big toe side of leg or foot | THENAR | of the ball of the thumb |
| ALVEOLAR | of the gums or tooth ridge | THORACIC | of the chest |
| COSTAL | of the ribs | | |

## BONES

| | | | |
|---|---|---|---|
| CALCANEUS | the heel bone | OLECRANON | the elbow bone |
| CARPUS | the wrist | PATELLA | the kneecap |
| CLAVICLE | the collarbone | PHALANGES | the finger and toe bones |
| COCCYX | the four fused vertebrae below the sacrum | PROCESS | a projecting part (also EMINENCE) |
| CONDYLE | a knob at the end of a bone | PUBIS | the pubic bone, part of the hip bone |
| COSTAE | the ribs | RADIUS | one of the arm bones |
| EPICONDYLE | a knob on or above a condyle | SACRUM | five fused vertebrae near the end of the spine |
| FEMUR | the thigh bone | | |
| FIBULA | one of the lower leg bones | SCAPULA | the shoulder blade |
| HUMERUS | the upper arm bone | STERNUM | the breastbone |
| ILIUM | one of the hip bones | TARSUS | the ankle, instep and heel bones |
| ISCHIUM | one of the hip bones | TIBIA | one of the lower leg bones |
| MALLEOLUS | a hammer-shaped prominence of a bone (e.g. in the ankle) | ULNA | one of the arm bones |
| | | VERTEBRA | one of the bones of the spine |
| MANDIBLE | the lower jawbone | ZYGOMATIC BONE | the cheekbone |
| MAXILLA | the upper jawbone | | |
| METACARPUS | the bones of the palm of the hand | | |
| METATARSUS | the bones of the front part of the foot, except the toes | | |

Many bones are named from their shapes: PISIFORM (pea-shaped), CUNEIFORM (wedge-shaped), SCAPHOID (boat-shaped), etc.

## MUSCLES

As outlined on pages 10–11, among the movements of the joints are flexion (bending to a narrower angle), extension (straightening), abduction (movement away from the midline of the body) and adduction (movement towards the midline). The muscles involved in such movements are FLEXORS, EXTENSORS, ABDUCTORS and ADDUCTORS. There are also ROTATORS.

Other muscles named from their functions are LEVATORS and DEPRESSORS, which respectively raise and lower some part of the body. A TENSOR tightens a part of the body and a DILATOR dilates it. The CORRUGATOR is the muscle that wrinkles the forehead above the nose (think of 'corrugated iron'!).

Muscles come in various sizes and the relative size is often indicated by a Latin adjective:

| | | | | |
|---|---|---|---|---|
| LONGUS | long | | Similarly with regard to position: | |
| BREVIS | short | | INTEROSSEI | between bones |
| MAGNUS | large | | LATERALIS | lateral, of or towards the side |
| MAJOR | larger | | MEDIALIS | medial, of or towards the middle |
| MAXIMUS | largest | | ORBICULARIS | round an opening |
| MEDIUS | middle | | PROFUNDUS | deep (opposite to SUPERFICIALIS) |
| MINOR | smaller | | (For ANTERIOR, POSTERIOR, INFERIOR and SUPERIOR, | |
| MINIMUS | smallest | | see the English terms opposite.) | |

## LATIN FORMS THAT INDICATE 'OF THE ...'

| | | | |
|---|---|---|---|
| ABDOMINIS | of the abdomen | LUMBORUM | of the loins |
| ANGULI ORIS | of the corner of the mouth | MENTALIS | of the chin |
| AURICULARIS | of the ear | NARIS | of the nostril |
| BRACHII | of the arm (also BRACHIALIS) | NASALIS | of the nose (also NASI) |
| CAPITIS | of the head | NUCHAE | of the nape of the neck |
| CARPI | of the wrist | OCULI | of the eye |
| CERVICIS | of the neck | ORIS | of the mouth |
| DIGITI | of a finger or toe | PALMARIS | of the palm |
| DIGITI MINIMI | of the little finger or toe | PATELLAE | of the kneecap |
| DIGITORUM | of the fingers or toes | PLANTAE | of the sole of the foot |
| DORSI | of the back | PECTORALIS | of the chest or breast |
| FASCIAE | of a fascia (see below) | POLLICIS | of the thumb |
| FEMORIS | of the femur | RADIALIS | of the radius |
| FRONTALIS | of the forehead | SCAPULAE | of the shoulder blade |
| HALLUCIS | of the big toe | THORACIS | of the chest |
| INDICIS | of the forefinger | TIBIALIS | of the tibia |
| LABII | of the lip | ULNARIS | of the ulna |

## OTHER PARTS OF THE BODY

| | | | |
|---|---|---|---|
| FASCIA | a sheet of connective tissue (*pl* FASCIAE) | FOSSA | a pit or hollow (*pl* FOSSAE) |

# The Full Figure

In this first section we look at the body as a whole, introducing the skeletal structure and the major muscles, then the proportions and the differences between male and female figures.

The bony skeleton is rather like interior scaffolding, around which the softer parts of the body are built. Of course, flesh and bone are not separate since the whole lot grows in the womb together, but the skeleton provides the rigid framework that supports the mass of muscles and viscera. In a newborn, the bone structure is not able to support the body because the muscles have not developed sufficiently. As the child grows, it gains both muscular strength and an understanding of how to control its movements.

It is important for the artist to know which bits of the skeleton show on the surface of the body because, when drawing, it helps to relate the fixed points of the figure to the appearance of the more fleshy parts. Understanding the structure of the skeleton is the basic requirement for accurate figure drawing.

When you draw the human body, you cannot see exactly where the muscles start and end. However, if you know something about the configuration, you'll find it makes it easier to indicate the main shape of any muscle more accurately in your drawing.

It is a good idea to get some knowledge of the larger, more superficial muscles, because then you can refer to them in a life class to clarify which part of the body you are tackling. If you have a good teacher, he or she will know most of the larger muscle names.

One thing you have to bear in mind when you come to drawing the human figure from life is the fact that the muscles of every individual will have developed in different ways. A person who is an athlete will have a muscle structure that is much easier to see on the surface than someone who has led a more sedentary life. In general, women have a thicker layer of fatty tissue than men, and sometimes a muscle which is obvious on a man will be more subtle and softer-looking on a woman. Then, of course, either male or female may have a more fatty development of their surface area overall, which will make it harder to see how the muscles overlap one another.

Although we always see the human body from the outside, our knowledge of what lies beneath the skin will help to produce more significant and convincing drawings.

## FULL-FIGURE SKELETON
### FRONT VIEW

Here we show three simple views of the skeleton, the front, the back and the side (also called the anterior, the posterior and the lateral views). I have kept the number of bones named here to a minimum, since we will be going into greater detail when looking at the parts of the body in close-up.

### TORSO

Clavicle (collarbone)
Coracoid process
Scapula (shoulder blade)
Manubrium
Sternum (breastbone)
Costae (12 pairs of ribs)

5 lumbar vertebrae

Anterior superior iliac spine
Ilium

Symphysis pubis    Pubis (pubic bone)

### LEG AND FOOT (LOWER LIMB)

Head of femur

Lesser trochanter

Greater trochanter

Patella (kneecap)

Fibula

Tibia (shin bone)

Tarsus
Metatarsus
Phalanges (14 toe bones)

### SKULL

Frontal bone
Zygomatic bone (cheekbone)
Maxilla
Mandible (jawbone)
7 cervical vertebrae

### ARM AND HAND (UPPER LIMB)

Humerus

Radius
Ulna

Carpus (wrist bones)
Metacarpus

Phalanges (14 finger bones)

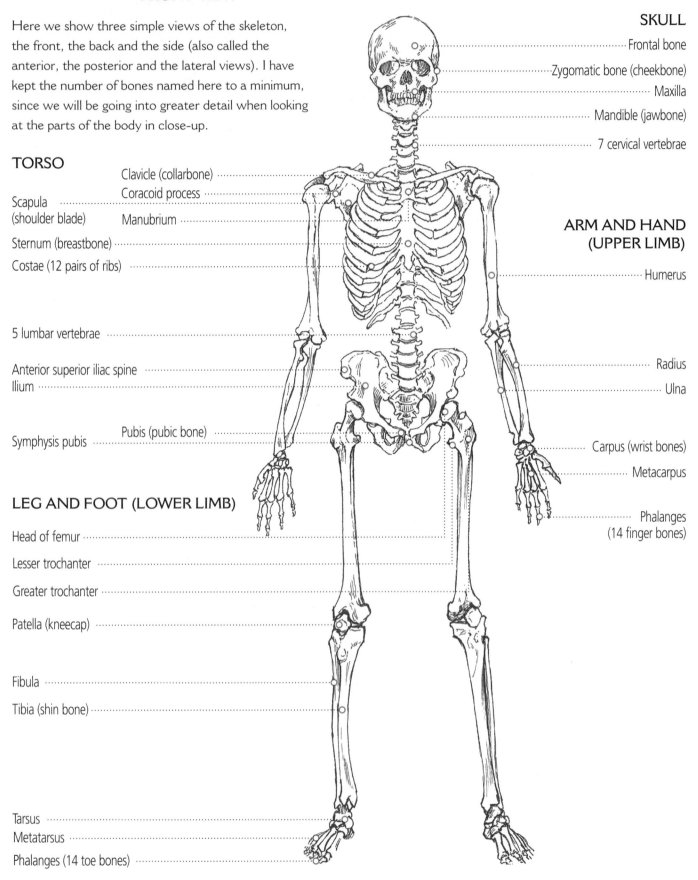

# FULL-FIGURE SKELETON
## BACK VIEW

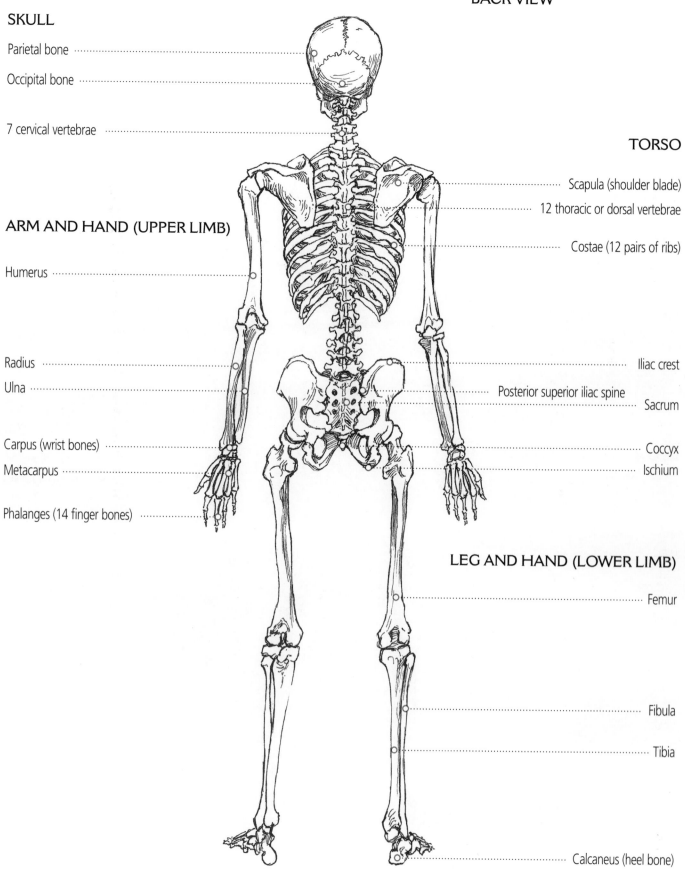

## SKULL

Parietal bone

Occipital bone

7 cervical vertebrae

## ARM AND HAND (UPPER LIMB)

Humerus

Radius

Ulna

Carpus (wrist bones)

Metacarpus

Phalanges (14 finger bones)

## TORSO

Scapula (shoulder blade)

12 thoracic or dorsal vertebrae

Costae (12 pairs of ribs)

Iliac crest

Posterior superior iliac spine

Sacrum

Coccyx

Ischium

## LEG AND HAND (LOWER LIMB)

Femur

Fibula

Tibia

Calcaneus (heel bone)

**FULL-FIGURE SKELETON**
SIDE VIEW

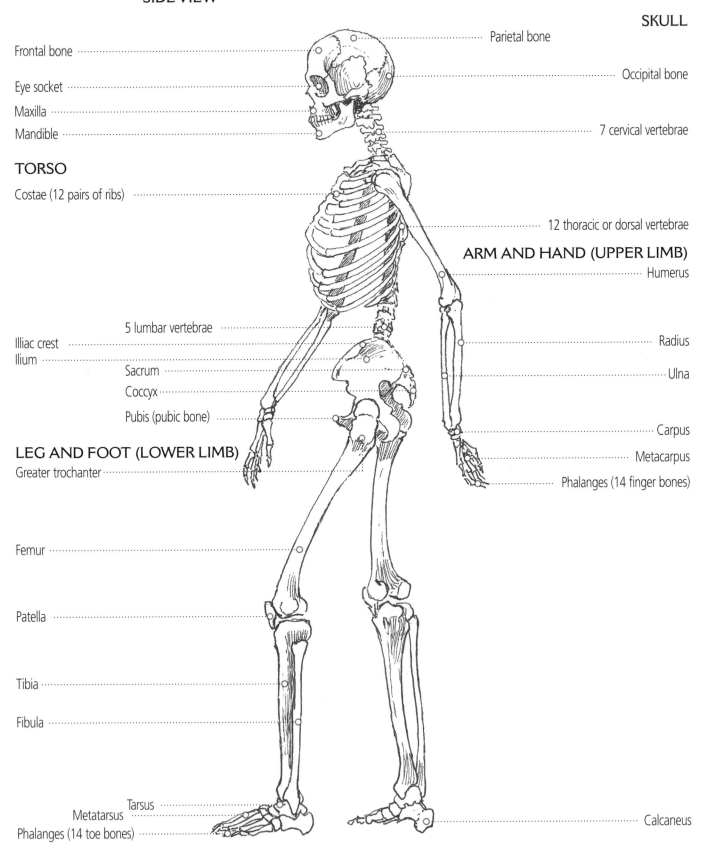

SKULL

Frontal bone ········································································ Parietal bone

Occipital bone

Eye socket

Maxilla

Mandible ·············································································· 7 cervical vertebrae

**TORSO**

Costae (12 pairs of ribs) ·················································

12 thoracic or dorsal vertebrae

ARM AND HAND (UPPER LIMB)

Humerus

5 lumbar vertebrae

Illiac crest                                                                Radius
Ilium

Sacrum                                                                     Ulna

Coccyx

Pubis (pubic bone) ·····················································

Carpus

**LEG AND FOOT (LOWER LIMB)**

Metacarpus

Greater trochanter ·····················································      Phalanges (14 finger bones)

Femur ··························································

Patella ·····················································

Tibia ·····················································

Fibula ·····················································

Tarsus
Metatarsus                                                                 Calcaneus
Phalanges (14 toe bones) ·············································

# FULL FIGURE SHOWING THE MUSCLES
## FRONT VIEW

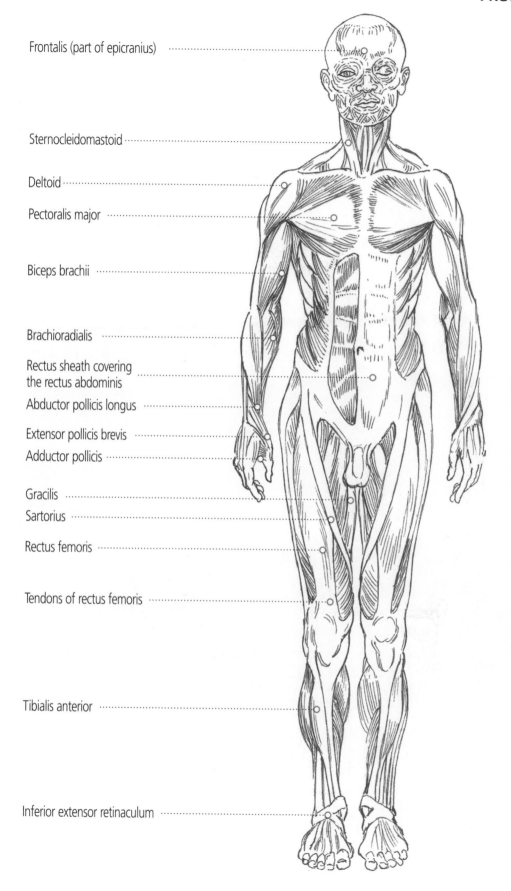

Frontalis (part of epicranius)

Sternocleidomastoid

Deltoid

Pectoralis major

Biceps brachii

Brachioradialis

Rectus sheath covering
the rectus abdominis

Abductor pollicis longus

Extensor pollicis brevis

Adductor pollicis

Gracilis

Sartorius

Rectus femoris

Tendons of rectus femoris

Tibialis anterior

Inferior extensor retinaculum

We show here the musculature of the whole body, to give an idea of the complexity of the sheaths of muscles over the bone structure. Later in the book we shall also be looking at some of the deeper muscles in the body, but here only the more superficial muscles are on show.

The drawings that follow are based on a male body. Of course there are slight differences between the male and female musculature, but not much in the underlying structure. The main differences are in the chest area and the pubic area. There are also slight proportional differences and we will look at these later in the chapter. But this complete human figure will give you a good idea about how the muscles are placed over the body.

# FULL FIGURE SHOWING THE MUSCLES
## BACK VIEW

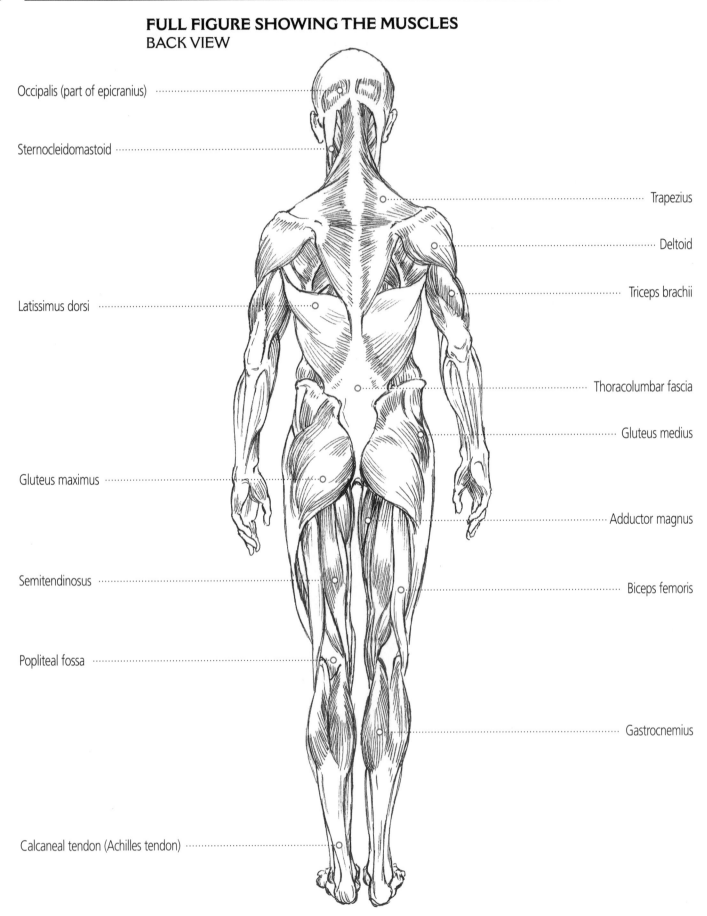

Occipalis (part of epicranius)

Sternocleidomastoid

Latissimus dorsi

Gluteus maximus

Semitendinosus

Popliteal fossa

Calcaneal tendon (Achilles tendon)

Trapezius

Deltoid

Triceps brachii

Thoracolumbar fascia

Gluteus medius

Adductor magnus

Biceps femoris

Gastrocnemius

# FULL FIGURE SHOWING THE MUSCLES
## SIDE VIEW

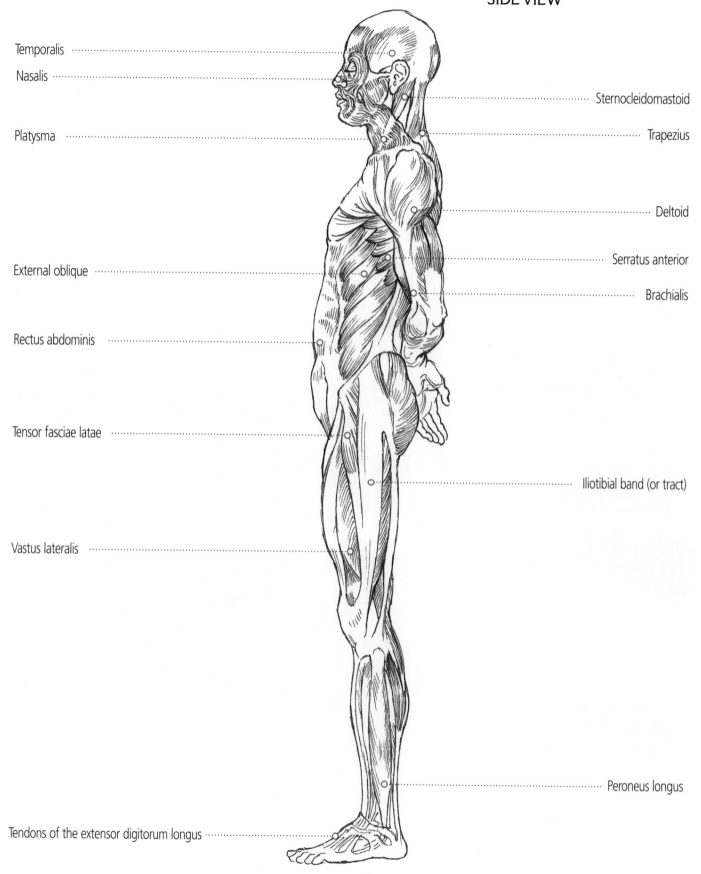

Temporalis

Nasalis

Platysma

External oblique

Rectus abdominis

Tensor fasciae latae

Vastus lateralis

Tendons of the extensor digitorum longus

Sternocleidomastoid

Trapezius

Deltoid

Serratus anterior

Brachialis

Iliotibial band (or tract)

Peroneus longus

# FULL FIGURE SHOWING THE SURFACE OF THE BODY
## FRONT VIEW – MALE

When you come to examine the surface of the human body, all the bones and muscles we have looked at are rather disguised by the layers of fat and skin that cover them. For the artist this becomes a sort of detective story, through the process of working out which bulges and hollows represent which features underneath the skin.

To make this easier, I have shown drawings of the body from the front, back and side, which are in a way as diagrammatic as the skeleton and the muscular figures on the previous pages. Because, on the surface, the male and female shapes become more differentiated, I have drawn both sexes. I have also included diagrams of the proportions of figures (see pages 28–31) to make it easier for you to draw the figure correctly.

Once again, I cannot stress enough that to draw the human figure effectively, you will eventually need to attend a life class at a local arts facility. Drawing from others' drawings and diagrams is useful, as is drawing from photographs, but you will never make entirely convincing drawings of people unless you also draw from life.

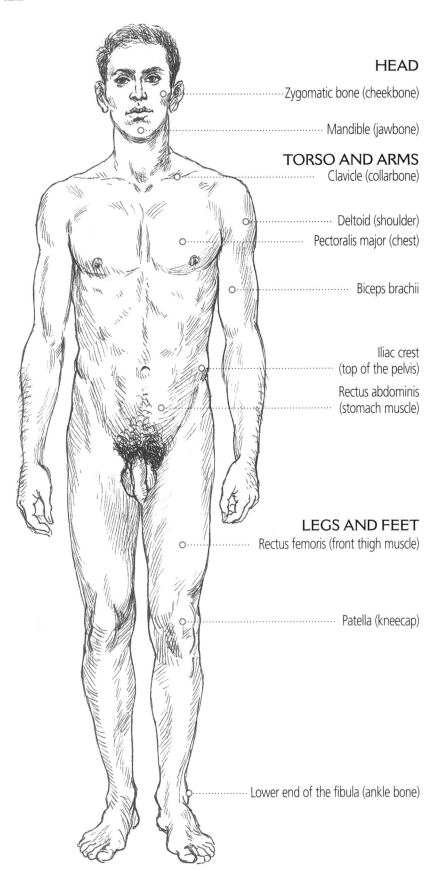

**HEAD**
Zygomatic bone (cheekbone)

Mandible (jawbone)

**TORSO AND ARMS**
Clavicle (collarbone)

Deltoid (shoulder)
Pectoralis major (chest)

Biceps brachii

Iliac crest
(top of the pelvis)
Rectus abdominis
(stomach muscle)

**LEGS AND FEET**
Rectus femoris (front thigh muscle)

Patella (kneecap)

Lower end of the fibula (ankle bone)

# FULL FIGURE SHOWING THE SURFACE OF THE BODY
## FRONT VIEW – FEMALE

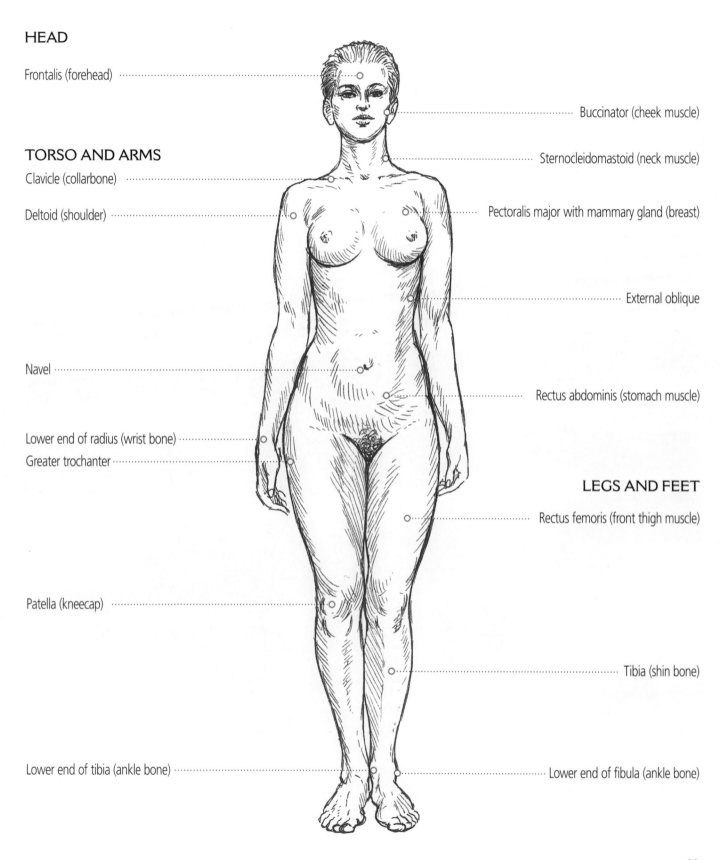

**HEAD**

Frontalis (forehead) ················

Buccinator (cheek muscle)

**TORSO AND ARMS**

Clavicle (collarbone) ················

Sternocleidomastoid (neck muscle)

Deltoid (shoulder) ················

Pectoralis major with mammary gland (breast)

External oblique

Navel ················

Rectus abdominis (stomach muscle)

Lower end of radius (wrist bone) ················

Greater trochanter ················

**LEGS AND FEET**

Rectus femoris (front thigh muscle)

Patella (kneecap) ················

Tibia (shin bone)

Lower end of tibia (ankle bone) ················

Lower end of fibula (ankle bone)

# FULL FIGURE SHOWING THE SURFACE OF THE BODY
## BACK VIEW – MALE

In this view, I have again highlighted the most prominent muscles and parts of the bone structure visible on the surface of the body. The difference between the male and female shapes is clear, in that the male shoulders are wider than any other part of the body, while the female hips and shoulders are of a similar width.

All these body shapes are based on an athletic form, because this shows more clearly the main features of muscle and bone.

Sternocleidomastoid (neck muscle)

Trapezius (top of shoulder)

Acromion

Deltoid (shoulder)

Scapula (shoulder blade)

Teres major

Triceps brachii

Spinal groove

Latissimus dorsi (lower back)

Iliac crest (top edge of pelvis)

Styloid process of radius

Gluteus maximus (buttock)

Biceps femoris (back of thigh)

Iliotibial band

Popliteal fossa (ham)

Gastrocnemius (calf muscle)

Soleus (outer calf)

Medial malleolus of tibia

Tendo calcaneus (Achilles tendon)

# FULL FIGURE SHOWING THE SURFACE OF THE BODY
## BACK VIEW – FEMALE

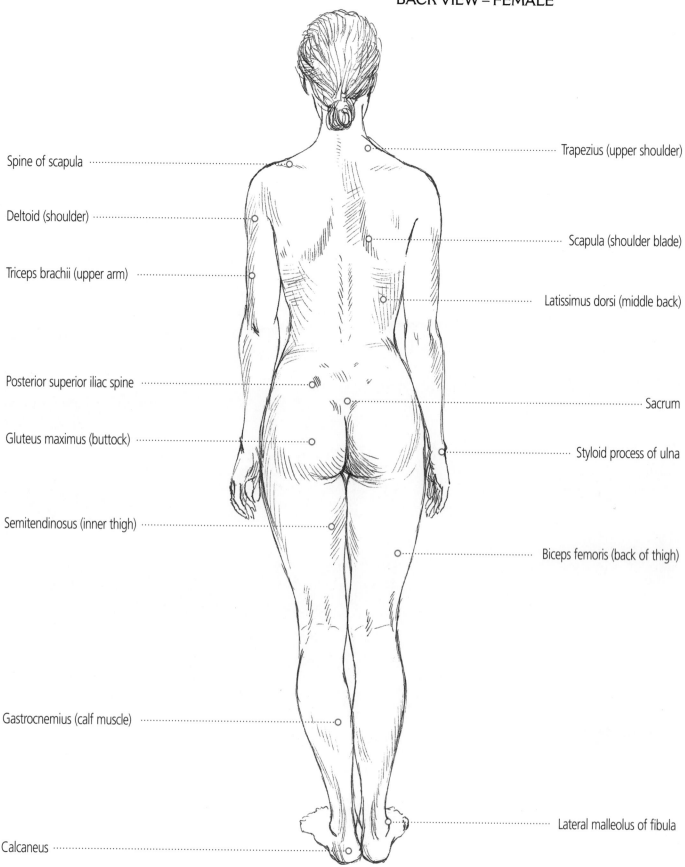

Spine of scapula

Deltoid (shoulder)

Triceps brachii (upper arm)

Posterior superior iliac spine

Gluteus maximus (buttock)

Semitendinosus (inner thigh)

Gastrocnemius (calf muscle)

Calcaneus

Trapezius (upper shoulder)

Scapula (shoulder blade)

Latissimus dorsi (middle back)

Sacrum

Styloid process of ulna

Biceps femoris (back of thigh)

Lateral malleolus of fibula

# FULL FIGURE SHOWING THE SURFACE OF THE BODY
## SIDE VIEW – MALE

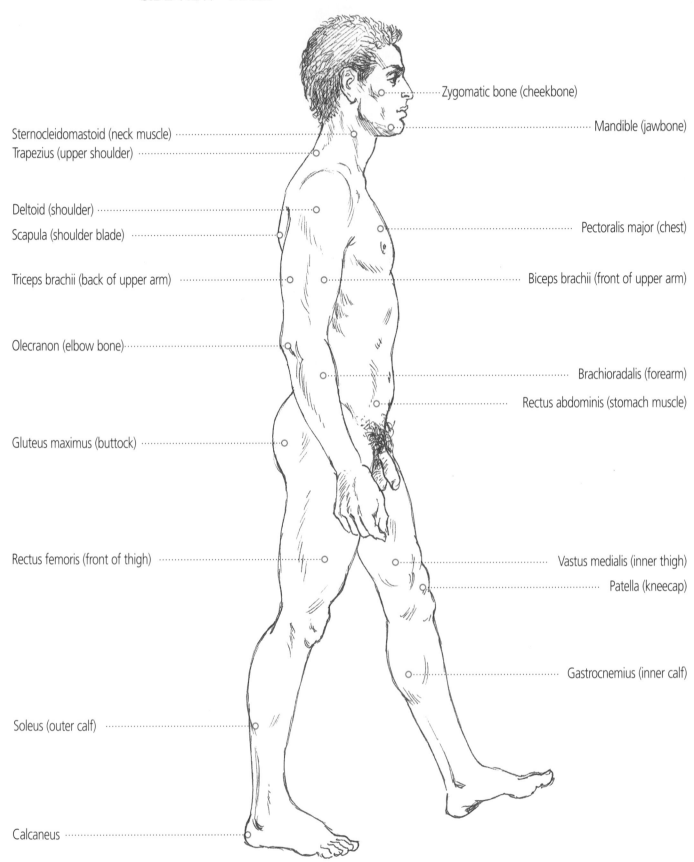

Zygomatic bone (cheekbone)

Mandible (jawbone)

Sternocleidomastoid (neck muscle)

Trapezius (upper shoulder)

Deltoid (shoulder)

Pectoralis major (chest)

Scapula (shoulder blade)

Triceps brachii (back of upper arm)

Biceps brachii (front of upper arm)

Olecranon (elbow bone)

Brachioradalis (forearm)

Rectus abdominis (stomach muscle)

Gluteus maximus (buttock)

Rectus femoris (front of thigh)

Vastus medialis (inner thigh)

Patella (kneecap)

Gastrocnemius (inner calf)

Soleus (outer calf)

Calcaneus

# FULL FIGURE SHOWING THE SURFACE OF THE BODY
## SIDE VIEW – FEMALE

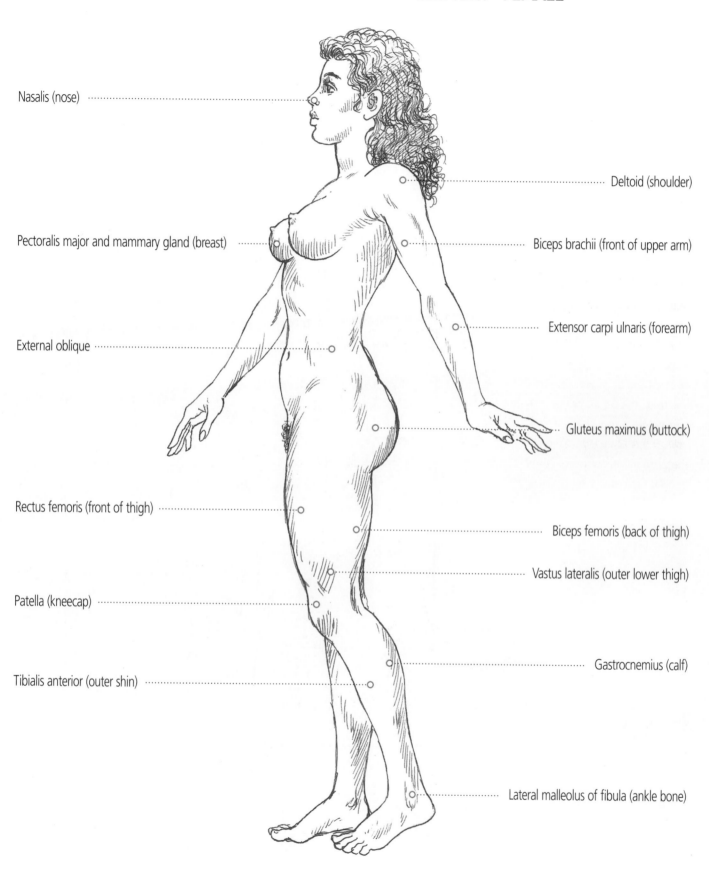

Nasalis (nose)

Pectoralis major and mammary gland (breast)

External oblique

Rectus femoris (front of thigh)

Patella (kneecap)

Tibialis anterior (outer shin)

Deltoid (shoulder)

Biceps brachii (front of upper arm)

Extensor carpi ulnaris (forearm)

Gluteus maximus (buttock)

Biceps femoris (back of thigh)

Vastus lateralis (outer lower thigh)

Gastrocnemius (calf)

Lateral malleolus of fibula (ankle bone)

# PROPORTIONAL VIEW OF THE HUMAN BODY
## MALE

In these diagrams, the basic unit of measurement is the length of the head, from the highest point on the top of the skull to the bottom of the chin. The length of the body – from the top of the head to the soles of the feet – is subdivided by the length of the head.

To the left of the male figure is the scale of classical proportion, which makes the head go into the length of the body eight times. This isn't quite accurate, although there may be some tall people with small heads that could fit the scale. It was considered ideal at one time because, drawn like that, the figure had a certain grandeur about it, and so this scale was used for the proportions of heroic and godlike figures.

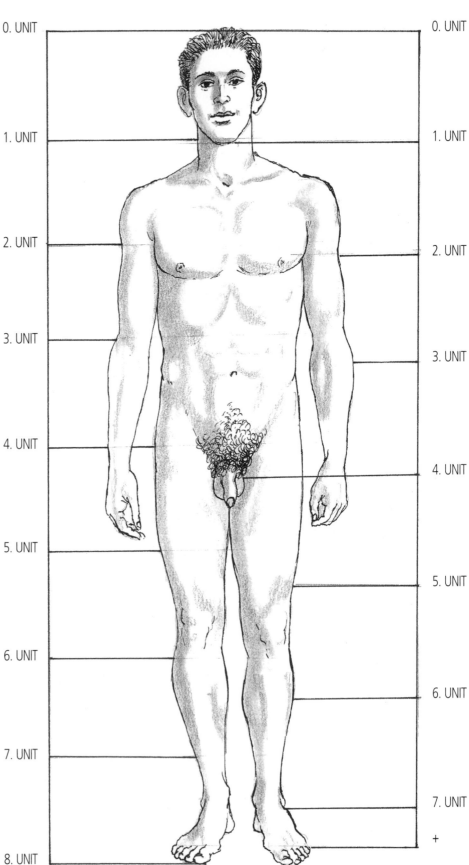

0. UNIT

1. UNIT

2. UNIT

3. UNIT

4. UNIT

5. UNIT

6. UNIT

7. UNIT

8. UNIT

0. UNIT

1. UNIT

2. UNIT

3. UNIT

4. UNIT

5. UNIT

6. UNIT

7. UNIT

+

## PROPORTIONAL VIEW OF THE HUMAN BODY
### FEMALE

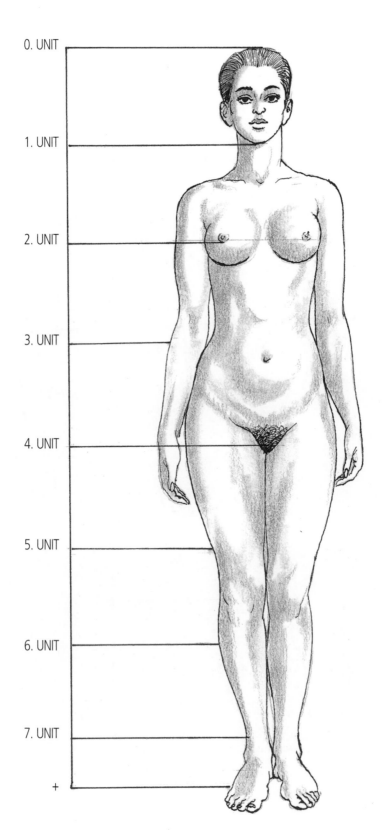

0. UNIT

1. UNIT

2. UNIT

3. UNIT

4. UNIT

5. UNIT

6. UNIT

7. UNIT

+

In fact, most human beings are closer to one head going seven-and-a-half times into the body length. This is the scale shown to the right of the male figure and on the female figure. Even this is an approximation, because not everyone fits the proportion quite so neatly. However, it can be applied to most figures.

What this proportion shows is that two units down from the top of the head marks the position of the nipples on the chest. Three units down from the top marks the position of the navel. Four units down marks the point where the legs divide.

By comparing these two different systems of measurement, you can see that the proportion of one to eight could be made to work, but the proportion of one to seven-and-a-half is closer to reality.

# PROPORTIONS AT DIFFERENT AGES FROM 1–25 YEARS

These drawings show the changes in proportion of the human body (male) at different ages. At one year old, only four head lengths fit into the full height of the body, whereas at almost 25 years old, the head will go into the length of the body about seven-and-a-half times.

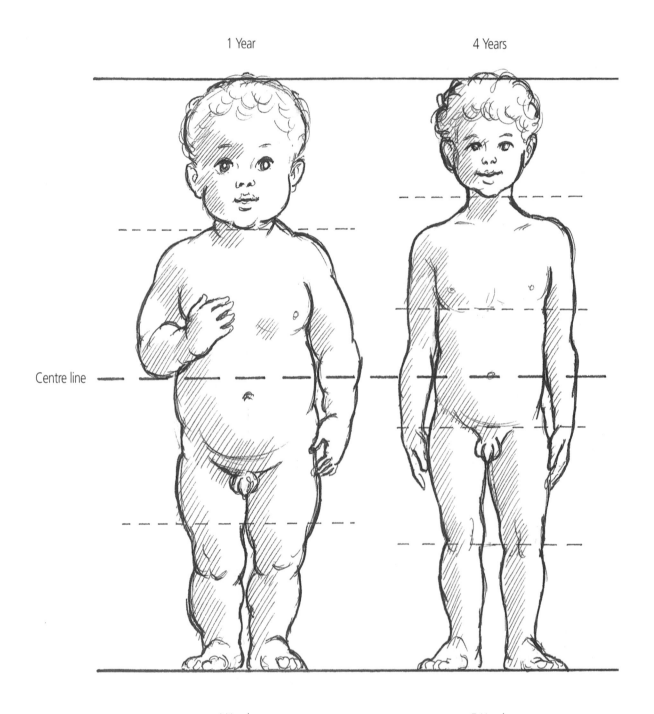

1 Year

4 Years

Centre line

4 Heads

5 Heads

# PROPORTIONS AT DIFFERENT AGES FROM 1–25 YEARS

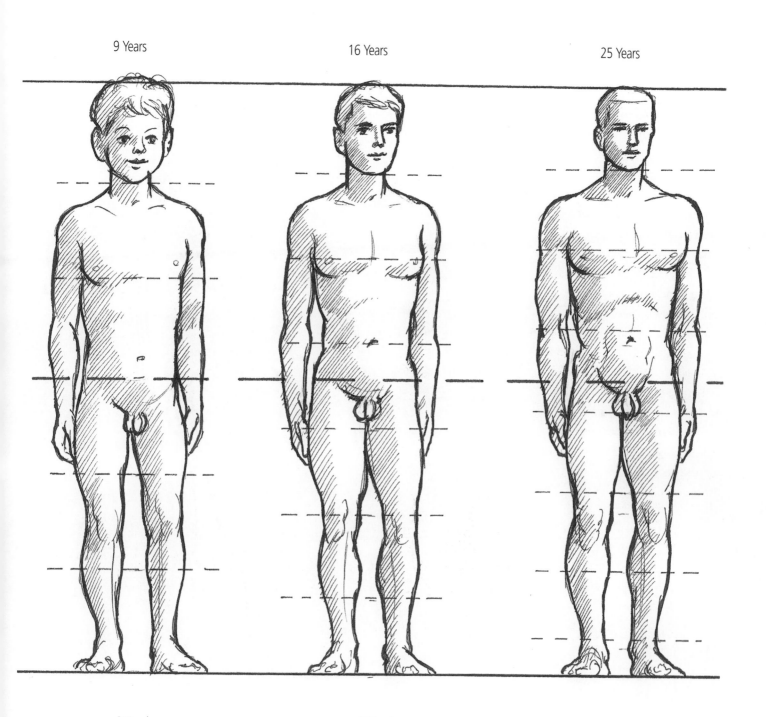

9 Years

16 Years

25 Years

6 Heads

7 Heads

7 ½ Heads

# DIFFERENCES BETWEEN THE MALE AND FEMALE SKELETON

There are differences in structure between the male and female skeleton and between some of the surface muscles. Over the next few pages, I have illustrated those differences that can be identified fairly easily when drawing a figure. Of course, bear in mind that body shape varies widely. Some female figures are nearer to the masculine shape, and vice versa.

Generally speaking, the bones of a female skeleton are smaller and more slender than those of a male skeleton. Also the surface of the bone is usually rougher in the male and smoother in the female.

The female ribcage is more conical in shape and the breastbone is shorter than the male's; this gives an appearance to female shoulders of sloping more than the male shoulders. In the male skeleton, the thorax is longer and larger, and the breastbone longer; this makes the shoulders look squarer and the neck shorter.

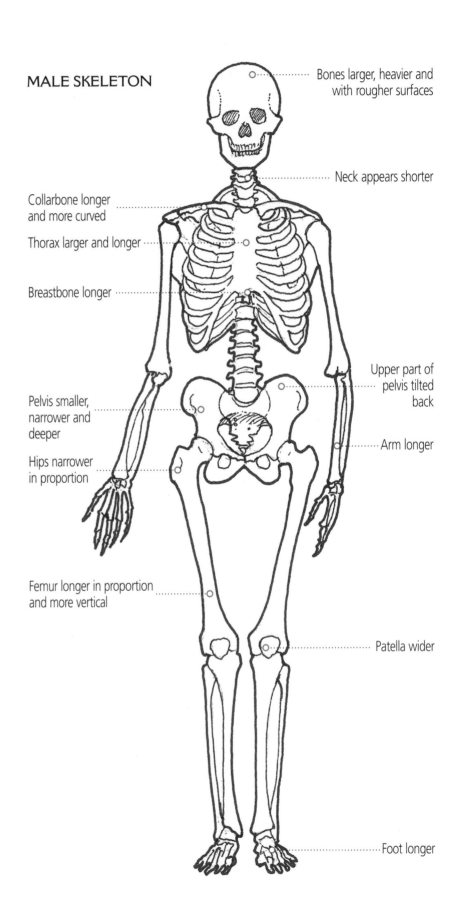

MALE SKELETON

Bones larger, heavier and with rougher surfaces

Neck appears shorter

Collarbone longer and more curved

Thorax larger and longer

Breastbone longer

Upper part of pelvis tilted back

Pelvis smaller, narrower and deeper

Arm longer

Hips narrower in proportion

Femur longer in proportion and more vertical

Patella wider

Foot longer

# DIFFERENCES BETWEEN THE MALE AND FEMALE SKELETON

## FEMALE SKELETON

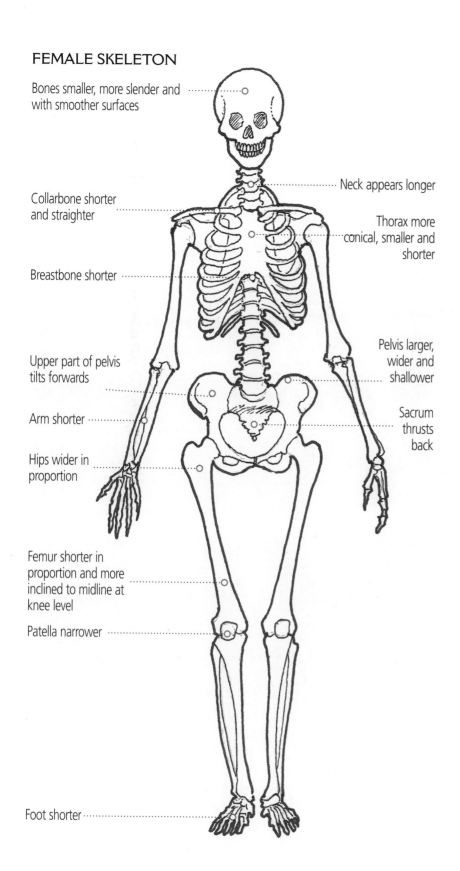

Bones smaller, more slender and with smoother surfaces

Collarbone shorter and straighter

Breastbone shorter

Upper part of pelvis tilts forwards

Arm shorter

Hips wider in proportion

Femur shorter in proportion and more inclined to midline at knee level

Patella narrower

Foot shorter

Neck appears longer

Thorax more conical, smaller and shorter

Pelvis larger, wider and shallower

Sacrum thrusts back

Another clear difference between the two sexes is in the disposition of the pelvis. In the female it is broader and shallower than in the male structure. The pubic arch is wider and the sacrum thrusts backwards, while the upper part of the pelvis is tilted forwards to accommodate pregnancy and provide the birth canal. In conjunction with this, the female thigh bone (the femur) is generally shorter and inclined more towards the midline at knee level than the male thigh. The effect of this is to make the hips of the female look wider in relation to her height.

Other differences are that the patella, or knee bone, is narrower in the female and the feet are shorter. This is all in proportion to the height of the full figure. Just as the leg is slightly shorter in the female skeleton, so also is the arm in relation to the rest of the skeleton. This all becomes more obvious when you see the skeleton covered with muscles, fat and skin, while in the skeleton itself it is not quite so noticeable. In some cases it is quite difficult to tell the difference between a male and a female skeleton.

# The Head

In the following sections we will explore each part of the body in greater detail, starting with the head and neck. As in the opening chapter, we begin by looking at the bone structure and then go on to study the musculature.

The skull, or cranium, is made up of several bones, although by the time an individual reaches puberty many of them have fused together in a process called ossification; in doing so they provide a solid case for the delicate instruments inside. The joins between these bones are called sutures.

At birth, the bones have not yet knitted together because they must be flexible during the birth process; and since the brain will grow quite a bit before adulthood, the sutures in a child's skull do not fuse completely for a number of years. The mandible (jawbone) grows dramatically as the child matures – an adult jaw is noticeably larger in proportion to the rest of the skull than that of a small child.

Although the muscles of the head are not very large in comparison with the rest of the body, they are significant because so many of them work to change our facial expressions. The face is the part of the body we respond to most and, as artists, the chief feature by which we capture a person's likeness.

The top of the head is generally covered in hair; the artist needs to determine the proportion of hair-covered head to face. So it is best to establish the hairline straightaway by sketching it in across the forehead and down as far as the ears. This defining line is most useful because it gives us a guide to positioning the facial features.

The shape and location of the eyes is very important; and the length and shape of the nose and the disposition of the mouth give us the rest of the expressive face. At the end of this section, we will investigate the facial expressions and features in detail.

## THE SKULL
### FRONT VIEW

The upper part of the skull contains the brain and the organs of sight and hearing. The front and rear parts consist of the thickest bone, where impacts are most likely; the sides of the head are much thinner. There are various openings in the case of the skull, such as the nose, ear holes and eye sockets. The latter contain smaller apertures for the passage of the optic nerves to the brain. Underneath we find the nasal cavities; also the foramen magnum,

through which the spinal column passes and connections are maintained between the brain and the rest of the body.

The lower part of the skull is the mandible, which houses the lower teeth and is hinged at the sides of the upper skull just below the ears. The first (milk) teeth fall out during childhood and are replaced by much larger adult teeth, which fill out the growing jaw.

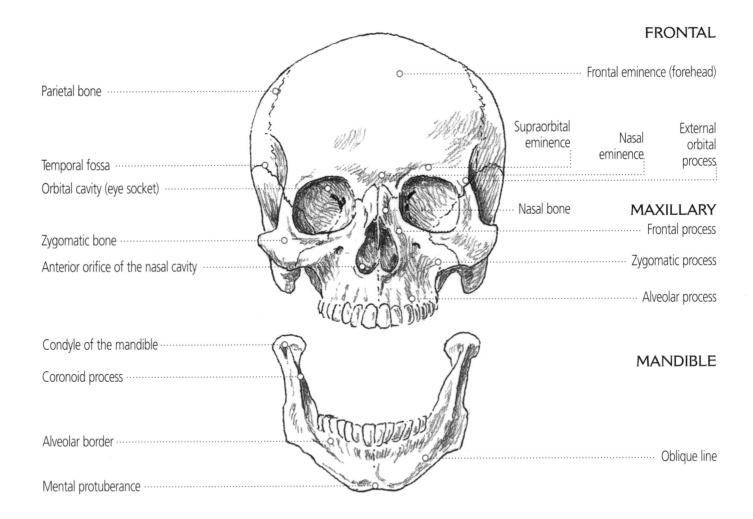

FRONTAL

Frontal eminence (forehead)

Parietal bone

Supraorbital eminence

Nasal eminence

External orbital process

Temporal fossa

Orbital cavity (eye socket)

Nasal bone

MAXILLARY

Frontal process

Zygomatic bone

Zygomatic process

Anterior orifice of the nasal cavity

Alveolar process

Condyle of the mandible

MANDIBLE

Coronoid process

Alveolar border

Oblique line

Mental protuberance

## THE SKULL
### SIDE AND TOP VIEW

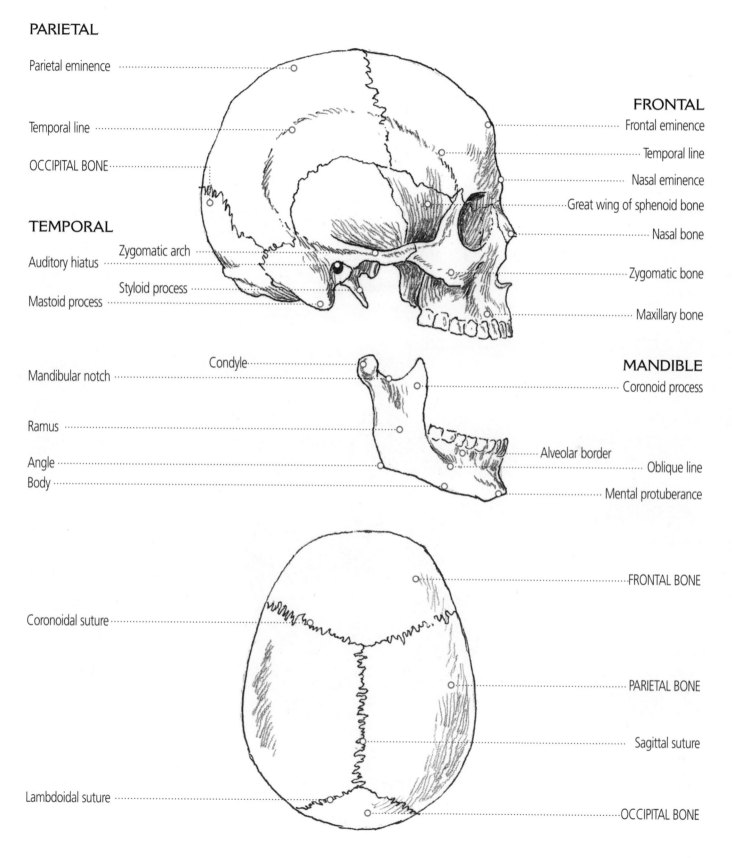

**PARIETAL**

Parietal eminence

Temporal line

OCCIPITAL BONE

**TEMPORAL**

Zygomatic arch

Auditory hiatus

Styloid process

Mastoid process

**FRONTAL**

Frontal eminence

Temporal line

Nasal eminence

Great wing of sphenoid bone

Nasal bone

Zygomatic bone

Maxillary bone

Condyle

Mandibular notch

Ramus

Angle

Body

**MANDIBLE**

Coronoid process

Alveolar border

Oblique line

Mental protuberance

Coronoidal suture

Lambdoidal suture

FRONTAL BONE

PARIETAL BONE

Sagittal suture

OCCIPITAL BONE

## THE SKULL
### BACK AND INSIDE VIEW

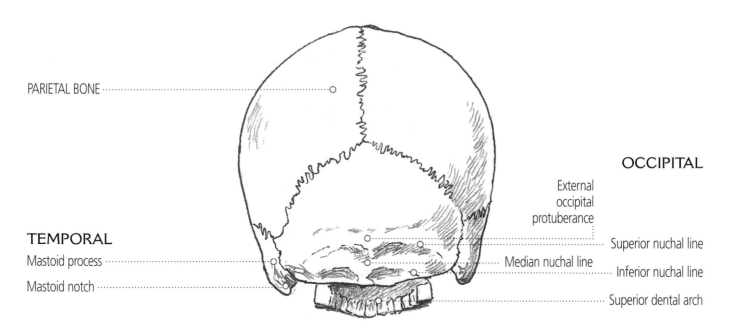

PARIETAL BONE .............................

OCCIPITAL

External occipital protuberance

TEMPORAL

Mastoid process .............................

Mastoid notch .............................

Superior nuchal line

Median nuchal line

Inferior nuchal line

Superior dental arch

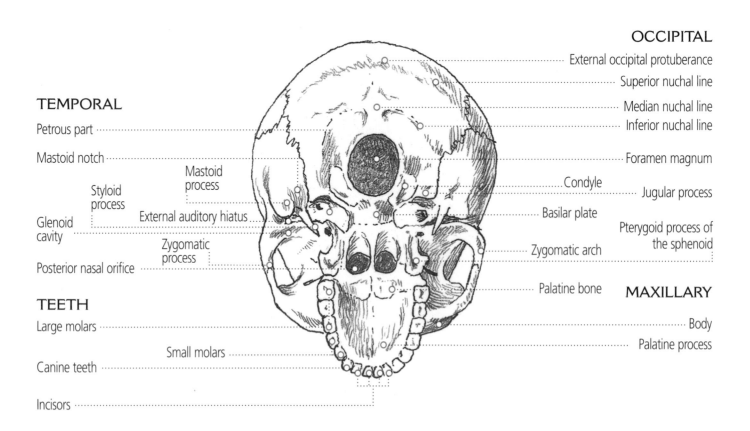

OCCIPITAL

External occipital protuberance

Superior nuchal line

Median nuchal line

Inferior nuchal line

Foramen magnum

Condyle

Jugular process

Basilar plate

Pterygoid process of the sphenoid

Zygomatic arch

Palatine bone

MAXILLARY

Body

Palatine process

TEMPORAL

Petrous part .............................

Mastoid notch .............................

Styloid process

Mastoid process

Glenoid cavity

External auditory hiatus

Zygomatic process

Posterior nasal orifice .............................

TEETH

Large molars .............................

Small molars .............................

Canine teeth .............................

Incisors .............................

## MUSCLES OF THE HEAD
### FRONT VIEW

These are the muscles that enable us to eat and drink, and of course they surround our organs of sight, sound, smell and taste. Although they don't have the physical power of the larger muscles of the limbs and trunk, they do play an important part in our lives.

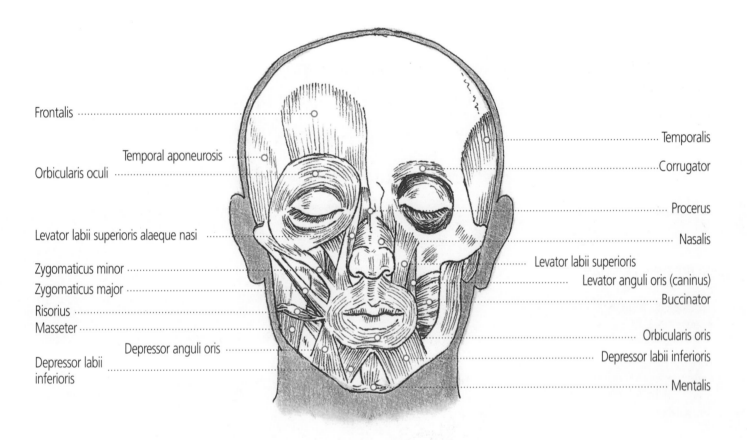

Frontalis

Temporal aponeurosis

Orbicularis oculi

Levator labii superioris alaeque nasi

Zygomaticus minor

Zygomaticus major

Risorius

Masseter

Depressor anguli oris

Depressor labii inferioris

Temporalis

Corrugator

Procerus

Nasalis

Levator labii superioris

Levator anguli oris (caninus)

Buccinator

Orbicularis oris

Depressor labii inferioris

Mentalis

## MUSCLES OF THE HEAD
### SIDE VIEW

**DEEP LAYER**

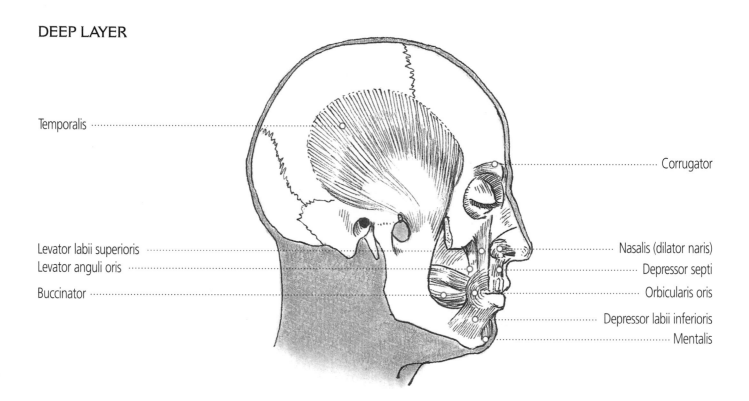

Temporalis

Levator labii superioris
Levator anguli oris

Buccinator

Corrugator

Nasalis (dilator naris)
Depressor septi
Orbicularis oris
Depressor labii inferioris
Mentalis

**SUPERFICIAL LAYER**

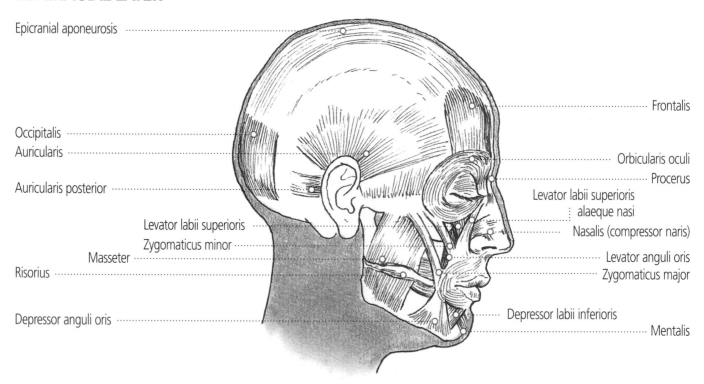

Epicranial aponeurosis

Occipitalis
Auricularis

Auricularis posterior

Levator labii superioris
Zygomaticus minor
Masseter
Risorius

Depressor anguli oris

Frontalis

Orbicularis oculi
Procerus
Levator labii superioris
  alaeque nasi
Nasalis (compressor naris)
Levator anguli oris
Zygomaticus major

Depressor labii inferioris
Mentalis

# STRUCTURE AND MUSCLES OF THE NECK
## FRONT AND SIDE VIEW

I have included the muscles of the neck with the head because, in most respects, their effect can be closely aligned with the head structure.

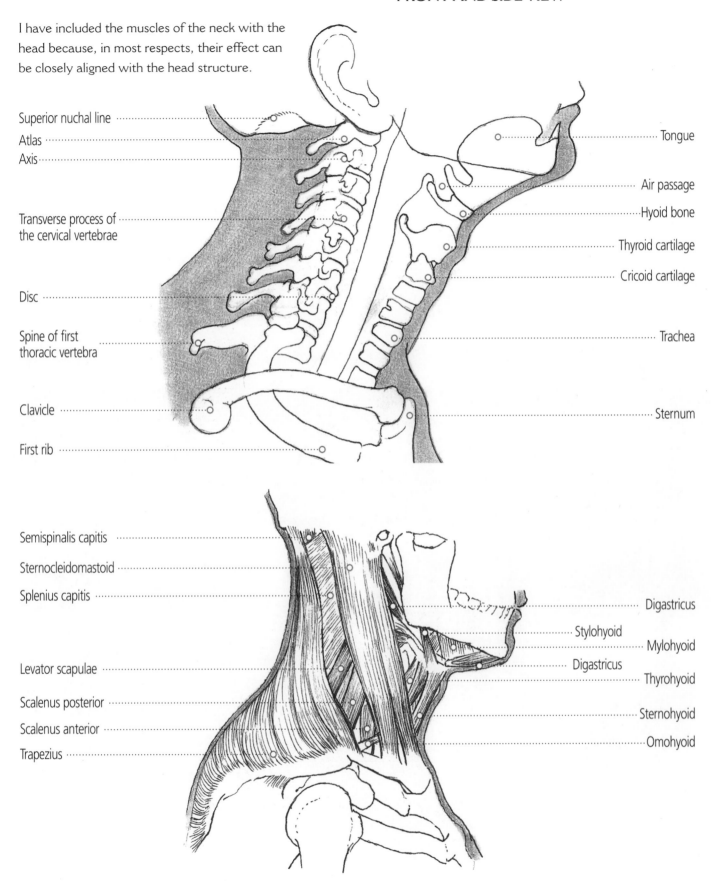

Superior nuchal line

Atlas

Axis

Transverse process of
the cervical vertebrae

Disc

Spine of first
thoracic vertebra

Clavicle

First rib

Tongue

Air passage

Hyoid bone

Thyroid cartilage

Cricoid cartilage

Trachea

Sternum

Semispinalis capitis

Sternocleidomastoid

Splenius capitis

Levator scapulae

Scalenus posterior

Scalenus anterior

Trapezius

Digastricus

Stylohyoid

Mylohyoid

Digastricus

Thyrohyoid

Sternohyoid

Omohyoid

# THE HEAD FROM DIFFERENT ANGLES

The head is often observed turning from full face towards a profile view. Looking at the full face (1), both eyes are the same shape, the mouth is fully displayed, and the nose is indicated chiefly by the nostrils. As shown in our diagram, when the head turns, the features remain the same distance apart and stay in the same relationship horizontally.

However, as the head rotates away to a three-quarter view (2), we begin to see the shape of the nose becoming more evident, while the far side of the mouth compresses into a shorter line, and the eye farthest from our view appears smaller than the nearer one.

Continuing towards the profile or side view (3), the nose becomes more and more prominent, while one eye disappears completely. Only half of the mouth can now be seen and – given the perspective – this is quite short in length. Notice how the shape of the head also changes from a rather narrow shape – longer than it is broad – to quite a square one, where width and length are almost the same. We can also see the shape of the ear, which at full face was hardly noticeable.

1.                              2.                              3.

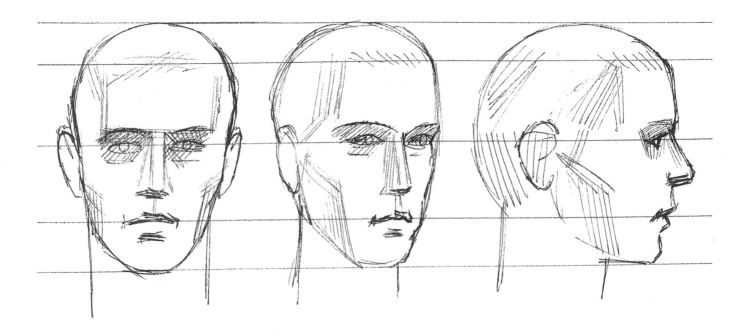

## THE HEAD FROM DIFFERENT ANGLES

Next, we shall look at the head in another sequence that opens with the full face, but this time the head will be lifted backwards with the chin tilting up, until very little of the face is seen from below.

Note at the beginning that the front view goes from the top of the head to the tip of the chin, and the facial features are all clearly visible.

Now, as we tilt the head backwards, we see less of the forehead and start to reveal the underside of the jaw and the nose. The end of the nose now seems to be about halfway down the head instead of three-quarters, as it was in the first diagram. The eyes appear narrower and the top of the head is invisible.

One more tilt of the head shows an even larger area underneath the jaw, and the mouth seems to curve downwards. The underside of the nose, with both nostrils very clearly visible, starts to look as though it is positioned between the eyes, which are even more narrowed now. The forehead is reduced to a small crescent shape and the cheekbones stand out more sharply. The ears, meanwhile, are descending to a position level with the chin, and the neck is very prominent.

One further tilt lifts the chin so high that we can now see its complete shape; and the nose, mouth and eyebrows are all so close together that they can hardly be seen. This angle of the head is unfamiliar to us, and is only usually seen when someone is lying down and we are looking up towards their head.

Note how the head looks vastly different from this angle, appearing as a much shorter, compacted shape.

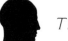 

# THE HEAD FROM DIFFERENT ANGLES

These examples show variations on viewing the head from slightly unusual angles, and you can see how they all suggest different expressions of the body's movement. Although the models for these drawings were not trying to express any particular feelings, the very fact of the movement of the head lends a certain element of drama to the drawings. This is because we don't usually move our heads without meaning something, and the inclination of the head one way or another looks as though something is meant by the action.

### LEANING BACK
### SEEN FROM BELOW

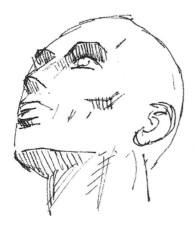

### LEANING FORWARD
### SEEN FROM ABOVE

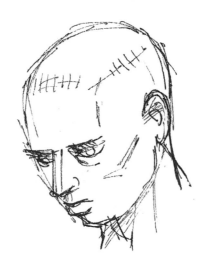

### LEANING BACK
### SEEN FROM BELOW

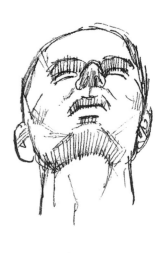

### CHIN TILTED UP
### SEEN IN PROFILE

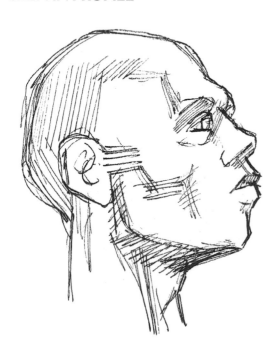

### THREE-QUARTER VIEW
### HEAD TILTED TOWARDS VIEWER

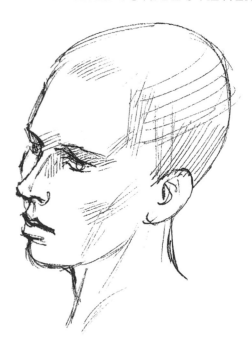



## THE HEAD FROM DIFFERENT ANGLES

THREE-QUARTER VIEW
SEEN FROM BELOW

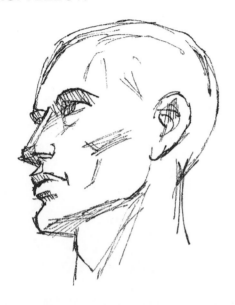

THREE-QUARTER VIEW
SEEN FROM SAME LEVEL

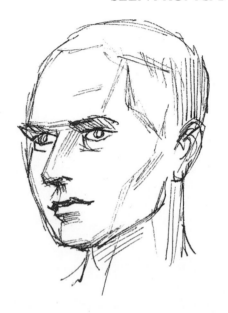

THREE-QUARTER VIEW FROM THE FRONT
SEEN FROM ALMOST THE SAME LEVEL

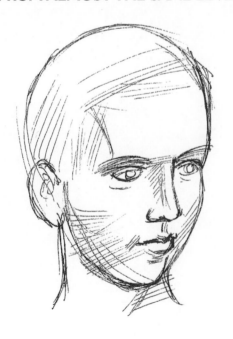

THREE-QUARTER VIEW
SEEN TILTED FORWARDS FROM ABOVE

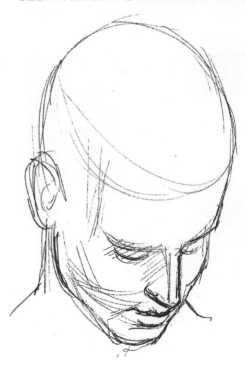

## FACIAL EXPRESSIONS

Now we move on to the other great challenge of drawing the head: capturing expression. Here are a series of expressions showing the dominant muscles. Check them and then persuade your friends or family to make similar faces, and see if you can identify the muscles responsible.

## MUSCLES USED WHEN SMILING, GRINNING AND LAUGHING

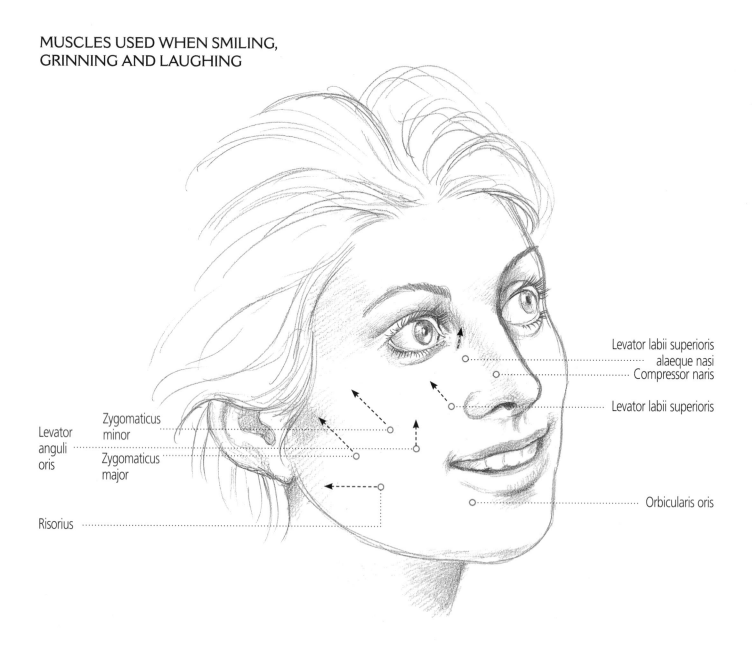

Levator anguli oris

Zygomaticus minor

Zygomaticus major

Risorius

Levator labii superioris alaeque nasi

Compressor naris

Levator labii superioris

Orbicularis oris

## FACIAL EXPRESSIONS

### SHOUTING OUT LOUD

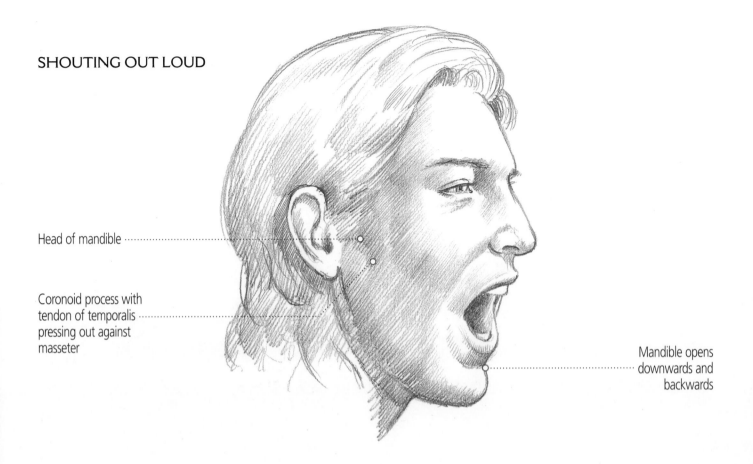

Head of mandible ·····························

Coronoid process with
tendon of temporalis
pressing out against
masseter

Mandible opens
downwards and
backwards

### FILLING CHEEKS
### WITH AIR TO BLOW

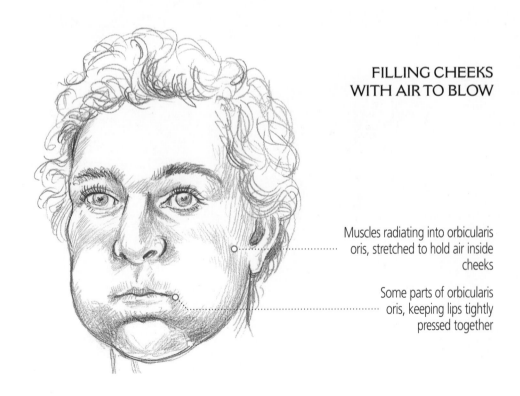

Muscles radiating into orbicularis
oris, stretched to hold air inside
cheeks

Some parts of orbicularis
oris, keeping lips tightly
pressed together

## FACIAL EXPRESSIONS

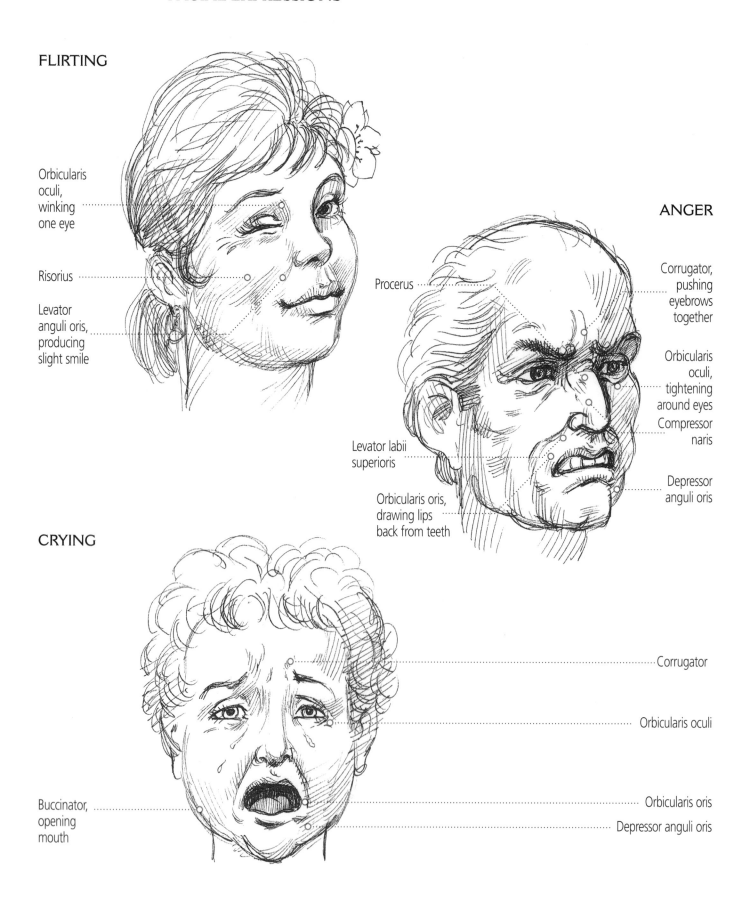

**FLIRTING**

Orbicularis oculi, winking one eye

Risorius

Levator anguli oris, producing slight smile

**ANGER**

Procerus

Corrugator, pushing eyebrows together

Orbicularis oculi, tightening around eyes

Compressor naris

Levator labii superioris

Depressor anguli oris

Orbicularis oris, drawing lips back from teeth

**CRYING**

Corrugator

Orbicularis oculi

Buccinator, opening mouth

Orbicularis oris

Depressor anguli oris

## FACIAL EXPRESSIONS

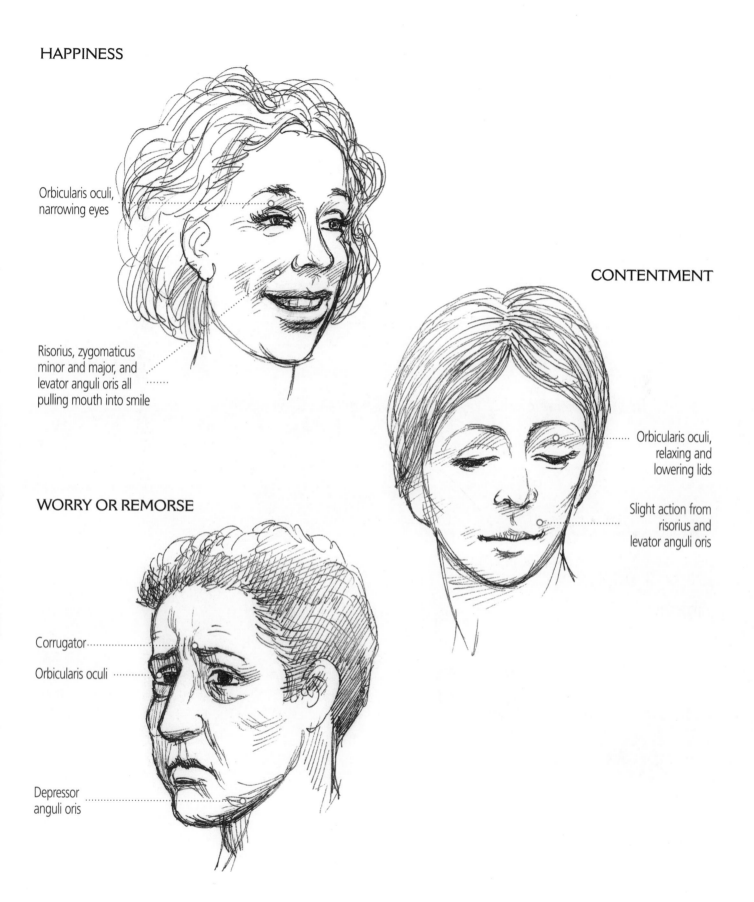

**HAPPINESS**

Orbicularis oculi, narrowing eyes

Risorius, zygomaticus minor and major, and levator anguli oris all pulling mouth into smile

**CONTENTMENT**

Orbicularis oculi, relaxing and lowering lids

Slight action from risorius and levator anguli oris

**WORRY OR REMORSE**

Corrugator

Orbicularis oculi

Depressor anguli oris

## FEATURES OF THE FACE IN DETAIL
### EYES

Here we show the individual features of the face: the eye, the mouth, the nose and the ear, giving some information about the normal formation of these features. What we will show is the basic structure of these features and their most obvious shape, but bear in mind that the features of individuals do vary quite dramatically sometimes.

First note that the normal position of the eye, when open and looking straight ahead, has part of the iris hidden under the upper eyelid, and the lower edge of the iris just touching the lower lid.

FRONT VIEW

Eyebrow

Form of orbital bone margin under eyebrow

Thicker lashes on upper eyelid

Upper lid

Pupil

Iris

Form of palpebral ligament

Thickness of lid

Lower lid

Thinner lashes on lower eyelid

Caruncle

Tear duct

Plica semilunaris

SIDE VIEW

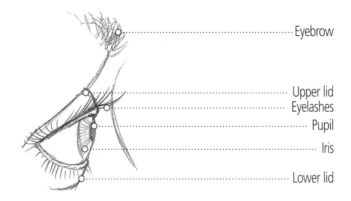

Eyebrow

Upper lid
Eyelashes
Pupil

Iris

Lower lid

Note the tendency of the eye's inner corner (medial canthus) to be slightly lower than the outer corner (lateral canthus), to help tear drainage.

## FEATURES OF THE FACE IN DETAIL
EYES

VARIOUS EYE SHAPES

NARROW EYES

ROUND EYES

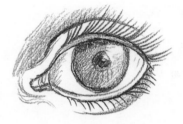

HEAVY-LIDDED
EYES

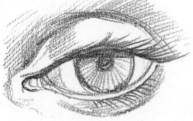

EAST ASIAN
EYES

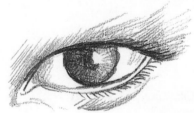

## FEATURES OF THE FACE IN DETAIL
MOUTHS

### FRONT VIEW
### NORMAL STRUCTURE OF LIPS

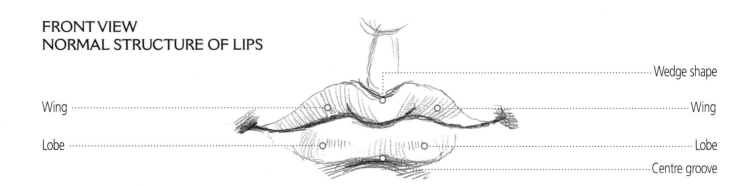

Wedge shape

Wing ........................................ Wing

Lobe ........................................ Lobe

Centre groove

## VARIOUS MOUTH SHAPES:

### FRONT VIEWS                                   SIDE VIEWS

**FULL LIPS**              **FULL LIPS**         **ANGLED: LOWER LIP BEHIND UPPER LIP**

**THIN LIPS**              **THIN LIPS**         **LOWER AND UPPER LIPS PROTRUDE THE SAME AMOUNT (POUTING)**

**AVERAGE 'CUPID'S BOW' LIPS**    **AVERAGE LIPS**    **ANGLED: LOWER LIP PROJECTING BEYOND UPPER LIP**

## FEATURES OF THE FACE IN DETAIL
### NOSES AND EARS

### NOSES: SIDE VIEWS

| LONG NOSE | SHORT STRAIGHT NOSE | AQUILINE NOSE | HOOK NOSE | BROKEN NOSE | RETROUSSÉ OR SNUB NOSE |
|---|---|---|---|---|---|

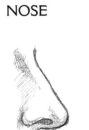 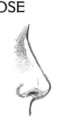 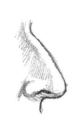 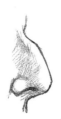 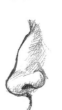 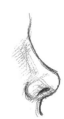

### FRONT VIEWS

**NORMAL, STRONG NOSE**

**RETROUSSÉ OR SNUB NOSE**

**AQUILINE NOSE**

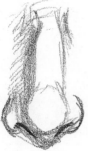  

### EARS

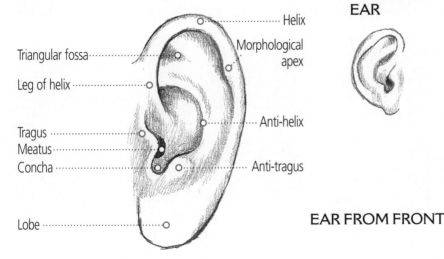

Helix

Triangular fossa

Morphological apex

Leg of helix

Tragus

Anti-helix

Meatus

Concha

Anti-tragus

Lobe

**ROUNDED EAR**

**EAR WITHOUT LOBE**

**ROUNDED EAR**

**EAR FROM FRONT**

**EAR FROM BACK**

As previously stated, there are enormous variations in the shapes of these features, and these pictures show only a few. However, their basic structure is the same and the artist needs to grasp this generalized information before exploring the detailed differences.

# The Torso

This section of the body is the most complicated and difficult for the artist to grasp because it performs so many functions and involves bones of several different types. The torso is capable of bending, stretching and twisting in all directions, thanks to the marvellous design and co-ordination of the spinal vertebrae, ribcage and pelvis.

Although they are flexible, these structures are also very stable owing to the fact that they have to contain and protect most of the major organs of the body. For instance, the ribs enclose the upper part of the torso and house within them the heart and lungs, while the pelvis supports 7.6 m (25 ft) of small and large intestine and the reproductive organs. The 26 spinal vertebrae run from the base of the skull through the cervical, thoracic and lumbar regions down to the pelvis, where they are immobile in the sacral area between the

hips, and end in the coccyx (fused tail bone). The vertebral column encases the spinal cord and connects the rest of the body to the brain and nervous system.

The torso also contains most of the body's largest broad or flat muscles, which help to cover and support the ribcage, vertebrae and pelvis. At the front, the pectorals and the rectus abdominis cover most of the surface area and are easily recognizable in an athletic figure. The shoulder and upper back muscles are very much involved with the movement of the arms, so it is sometimes difficult to decide where the torso muscles finish and those of the arm begin. This is equally true of the musculature surrounding the pelvis and the upper legs. The long valley of the vertebral column, down the centre of the back, is formed by the number of large muscles fanning out from the vertebrae and allows us to feel the bony structure underneath the surface of the skin.

# SKELETON OF THE HEAD AND TORSO
## FRONT VIEW

The thorax is the area of the trunk between the neck and the abdomen, including the sternum or breast bone, the 12 ribs or costae and the 12 thoracic vertebrae. These make up the thoracic cage (the ribcage) which protects the heart, lungs and viscera.

Below the thorax, the abdomen is made up of the lumbar vertebrae or column and the pelvic bones.

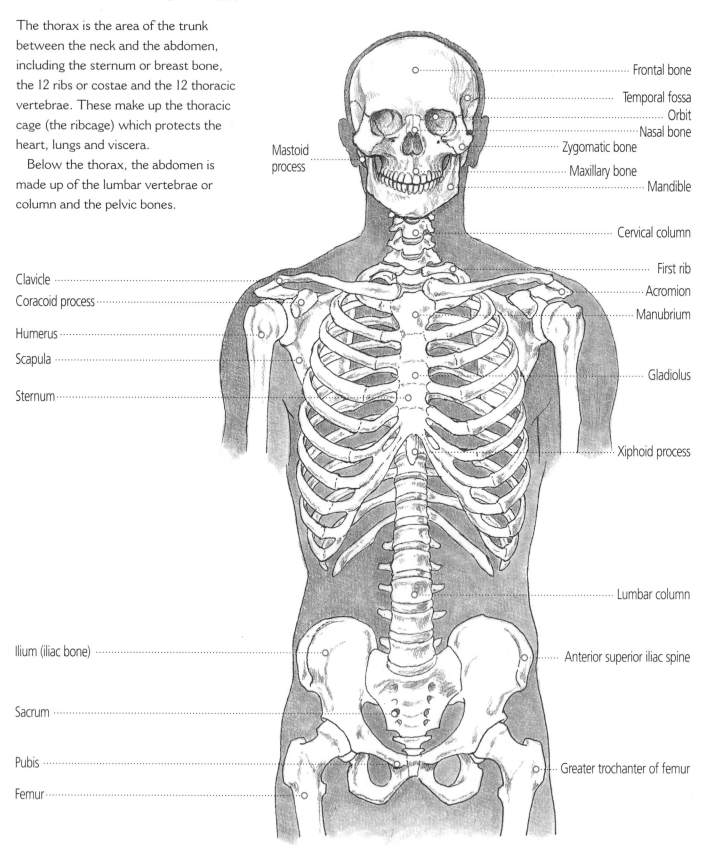

Frontal bone

Temporal fossa

Orbit

Nasal bone

Zygomatic bone

Maxillary bone

Mandible

Cervical column

First rib

Acromion

Manubrium

Gladiolus

Xiphoid process

Lumbar column

Anterior superior iliac spine

Greater trochanter of femur

Mastoid process

Clavicle

Coracoid process

Humerus

Scapula

Sternum

Ilium (iliac bone)

Sacrum

Pubis

Femur

# SKELETON OF THE HEAD AND TORSO
## BACK VIEW

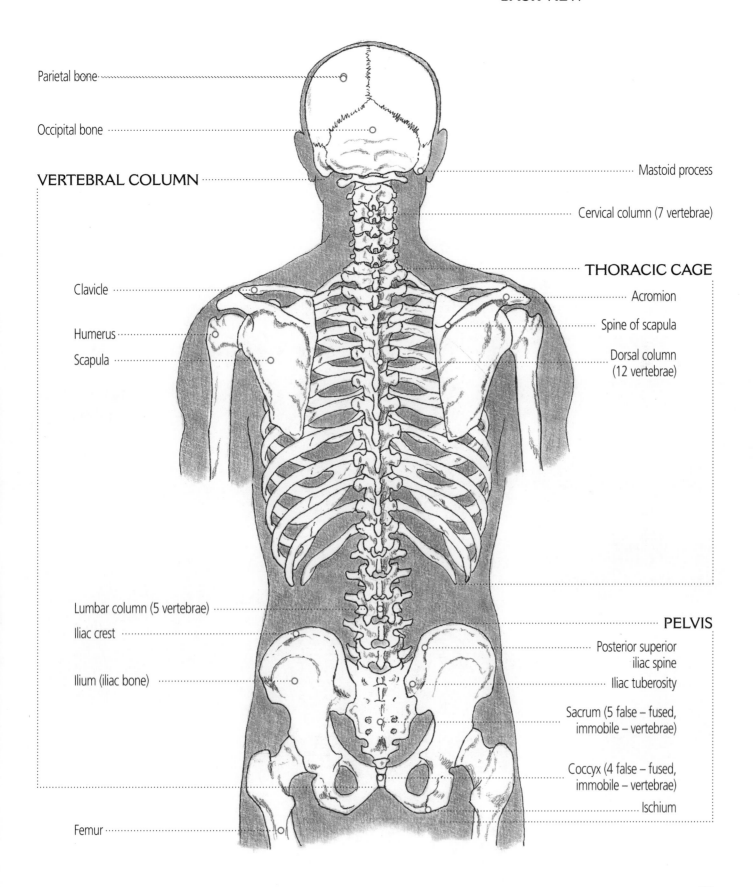

Parietal bone

Occipital bone

**VERTEBRAL COLUMN**

Clavicle

Humerus

Scapula

Lumbar column (5 vertebrae)

Iliac crest

Ilium (iliac bone)

Femur

Mastoid process

Cervical column (7 vertebrae)

**THORACIC CAGE**

Acromion

Spine of scapula

Dorsal column
(12 vertebrae)

**PELVIS**

Posterior superior
iliac spine

Iliac tuberosity

Sacrum (5 false – fused,
immobile – vertebrae)

Coccyx (4 false – fused,
immobile – vertebrae)

Ischium

## SKELETON OF THE HEAD AND TORSO
### SIDE VIEW

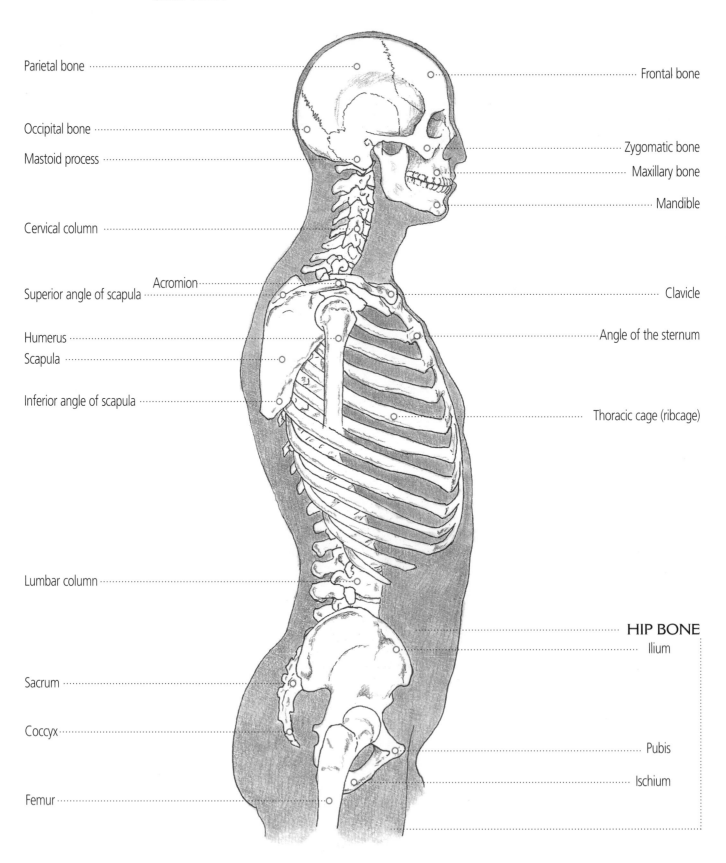

Parietal bone

Occipital bone

Mastoid process

Cervical column

Superior angle of scapula          Acromion

Humerus

Scapula

Inferior angle of scapula

Lumbar column

Sacrum

Coccyx

Femur

Frontal bone

Zygomatic bone

Maxillary bone

Mandible

Clavicle

Angle of the sternum

Thoracic cage (ribcage)

### HIP BONE
Ilium

Pubis

Ischium

# SKELETON: THE VERTEBRAL COLUMN
## SIDE VIEW

We examine the vertebral column by itself here because it is such an important part of the whole skeleton that it needs to be seen separately, without the distractions of the ribs and the pelvis. Note the curved form, and the way the parts are larger at the lower end and smaller at the higher end – a brilliant piece of natural architecture.

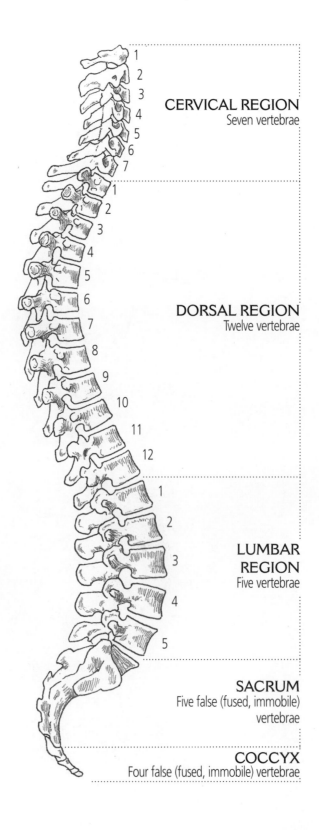

1
2
3
4
5
6
7

**CERVICAL REGION**
Seven vertebrae

1
2
3
4
5
6
7
8
9
10
11
12

**DORSAL REGION**
Twelve vertebrae

1
2
3
4
5

**LUMBAR REGION**
Five vertebrae

**SACRUM**
Five false (fused, immobile) vertebrae

**COCCYX**
Four false (fused, immobile) vertebrae

## SKELETON: THE PELVIS

**FRONT VIEW**

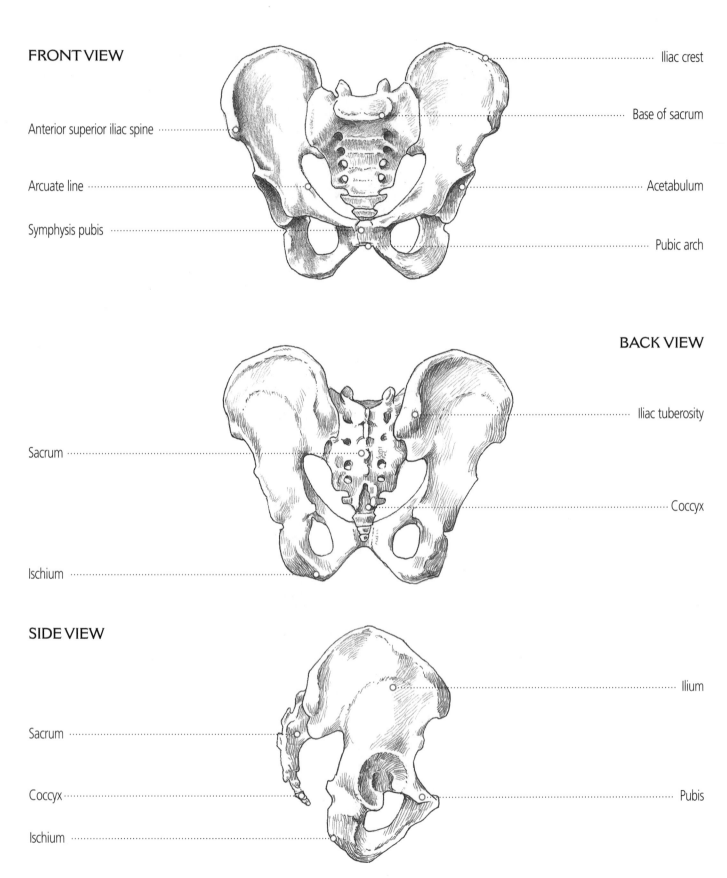

Anterior superior iliac spine

Arcuate line

Symphysis pubis

Iliac crest

Base of sacrum

Acetabulum

Pubic arch

**BACK VIEW**

Sacrum

Ischium

Iliac tuberosity

Coccyx

**SIDE VIEW**

Sacrum

Coccyx

Ischium

Ilium

Pubis

## MUSCLES OF THE TRUNK AND NECK
### FRONT VIEW

The muscles of the trunk are in the main quite large and fairly flat in shape. They are layered over the ribcage and pelvis and cover the big joints of the hips and shoulders. There are deeper layers of muscle in the back that sometimes help shape the more superficial muscles (see pages 66–67).

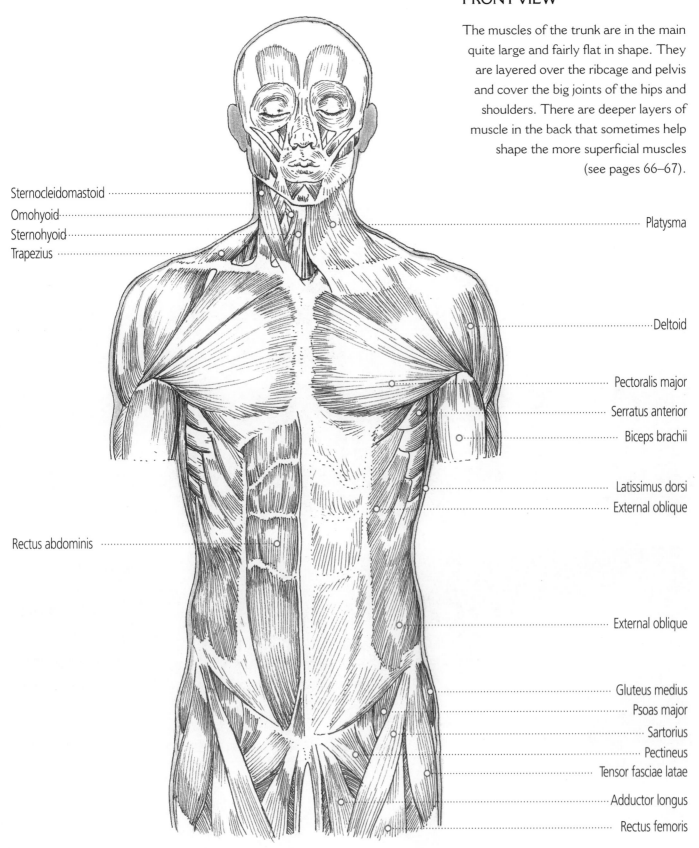

Sternocleidomastoid

Omohyoid

Sternohyoid

Trapezius

Rectus abdominis

Platysma

Deltoid

Pectoralis major

Serratus anterior

Biceps brachii

Latissimus dorsi

External oblique

External oblique

Gluteus medius

Psoas major

Sartorius

Pectineus

Tensor fasciae latae

Adductor longus

Rectus femoris

# MUSCLES OF THE TRUNK AND NECK
## BACK VIEW

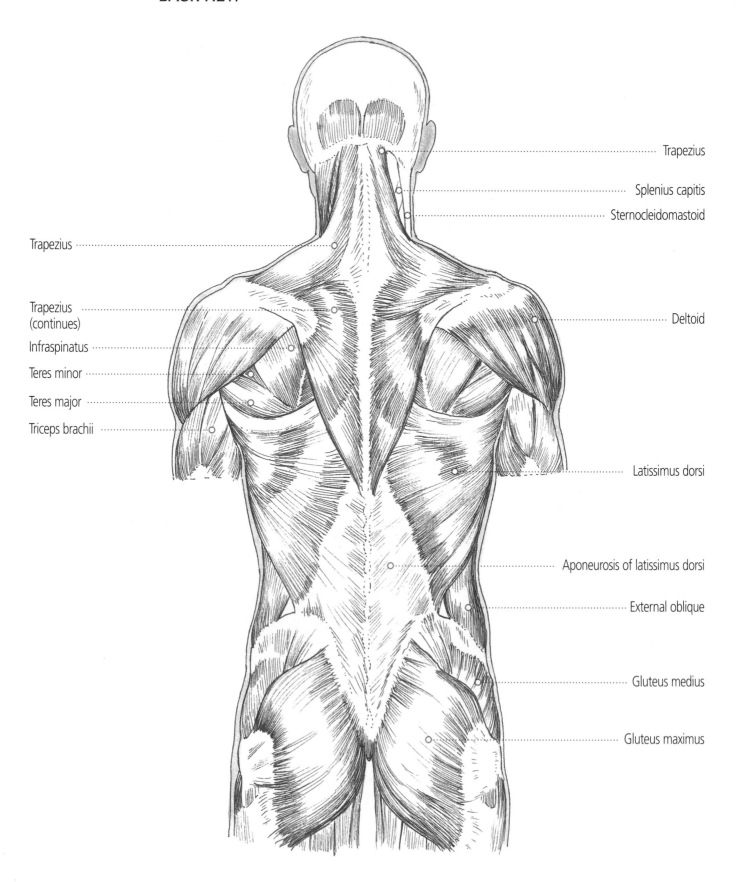

Trapezius

Splenius capitis

Sternocleidomastoid

Trapezius

Trapezius
(continues)

Infraspinatus

Teres minor

Teres major

Triceps brachii

Deltoid

Latissimus dorsi

Aponeurosis of latissimus dorsi

External oblique

Gluteus medius

Gluteus maximus

# MUSCLES OF THE TRUNK AND NECK
## SIDE VIEW

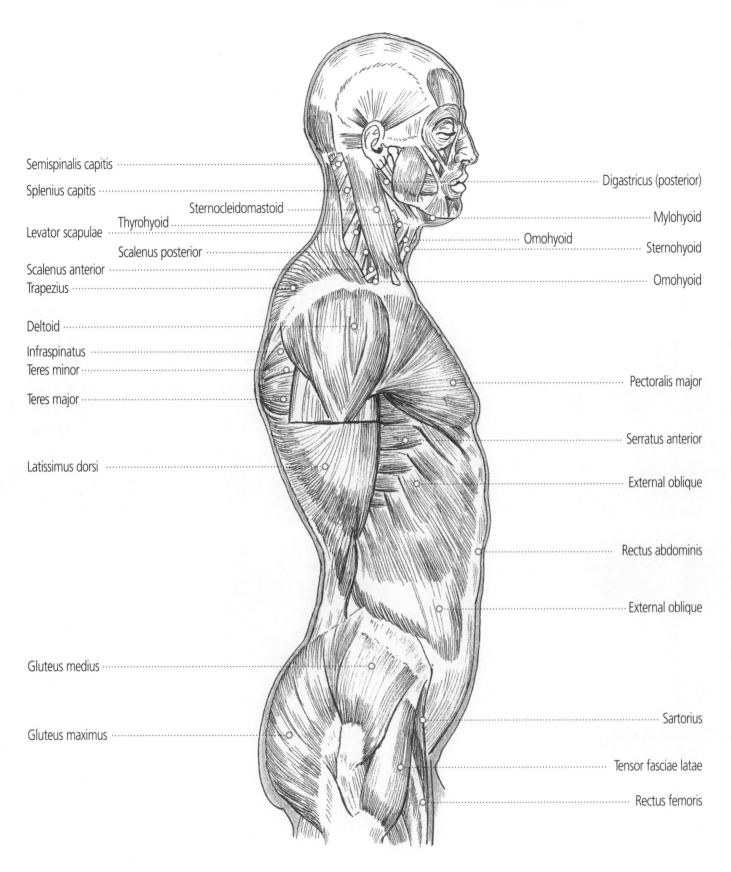

Semispinalis capitis

Splenius capitis

Sternocleidomastoid

Thyrohyoid

Levator scapulae

Scalenus posterior

Scalenus anterior

Trapezius

Deltoid

Infraspinatus

Teres minor

Teres major

Latissimus dorsi

Gluteus medius

Gluteus maximus

Digastricus (posterior)

Mylohyoid

Omohyoid

Sternohyoid

Omohyoid

Pectoralis major

Serratus anterior

External oblique

Rectus abdominis

External oblique

Sartorius

Tensor fasciae latae

Rectus femoris

## MUSCLES OF THE TRUNK AND NECK
### DEEPER MUSCLES, BACK VIEW

Here I show the deeper muscles first, and then the
mid-depth ones, with the bone structure of the
spinal column on the left-hand side.

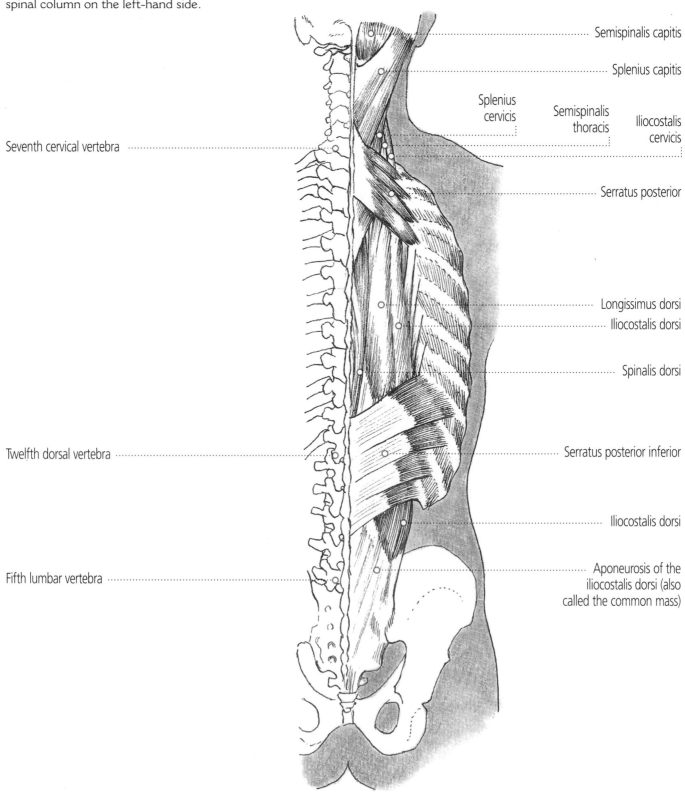

Semispinalis capitis

Splenius capitis

Splenius cervicis

Semispinalis thoracis

Iliocostalis cervicis

Seventh cervical vertebra

Serratus posterior

Longissimus dorsi

Iliocostalis dorsi

Spinalis dorsi

Twelfth dorsal vertebra

Serratus posterior inferior

Iliocostalis dorsi

Fifth lumbar vertebra

Aponeurosis of the iliocostalis dorsi (also called the common mass)

# MUSCLES OF THE TRUNK AND NECK
## MID-DEPTH MUSCLES, BACK VIEW

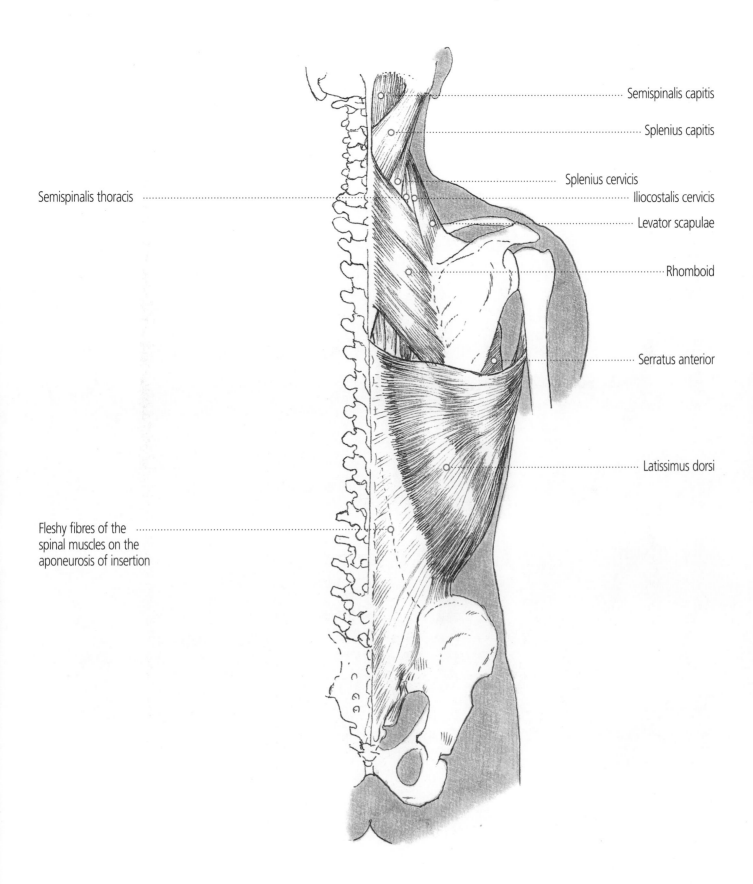

Semispinalis capitis

Splenius capitis

Splenius cervicis

Iliocostalis cervicis

Levator scapulae

Rhomboid

Serratus anterior

Latissimus dorsi

Semispinalis thoracis

Fleshy fibres of the
spinal muscles on the
aponeurosis of insertion

## SURFACE OF THE MALE TORSO
### FRONT AND SIDE VIEW

The surface view of the torso is deceptive, because only the large muscles are immediately obvious. This is particularly true of the front view since the inner organs are covered by large flat areas of the rectus abdominis. This layer is in turn covered by smooth aponeuroses and fasciae.

One thing that is clearly visible is the central line of the linea alba running down the front and the spinal groove on the back view. These both serve to highlight the balanced symmetry of the torso.

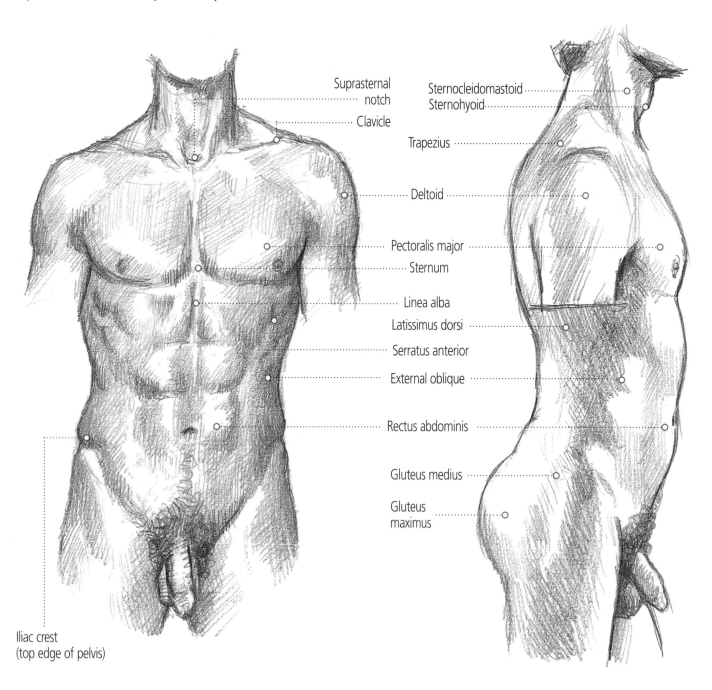

Suprasternal notch

Clavicle

Sternocleidomastoid
Sternohyoid

Trapezius

Deltoid

Pectoralis major

Sternum

Linea alba

Latissimus dorsi

Serratus anterior

External oblique

Rectus abdominis

Gluteus medius

Gluteus maximus

Iliac crest
(top edge of pelvis)

# SURFACE OF THE MALE TORSO
## BACK VIEW

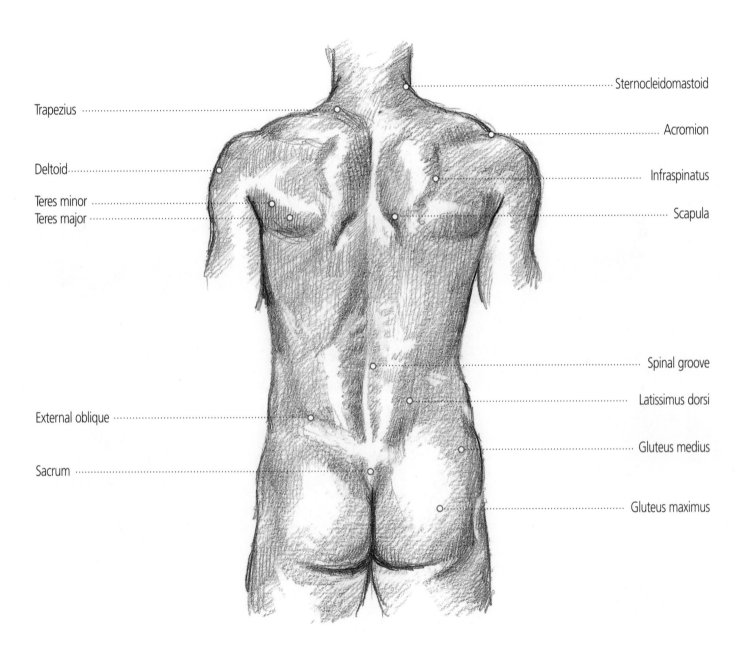

Trapezius

Deltoid

Teres minor
Teres major

External oblique

Sacrum

Sternocleidomastoid

Acromion

Infraspinatus

Scapula

Spinal groove

Latissimus dorsi

Gluteus medius

Gluteus maximus

## SURFACE OF THE FEMALE TORSO
### FRONT AND SIDE VIEW

Notice the difference between the ratio of the width of the
shoulders to the hips in the male and female torso.

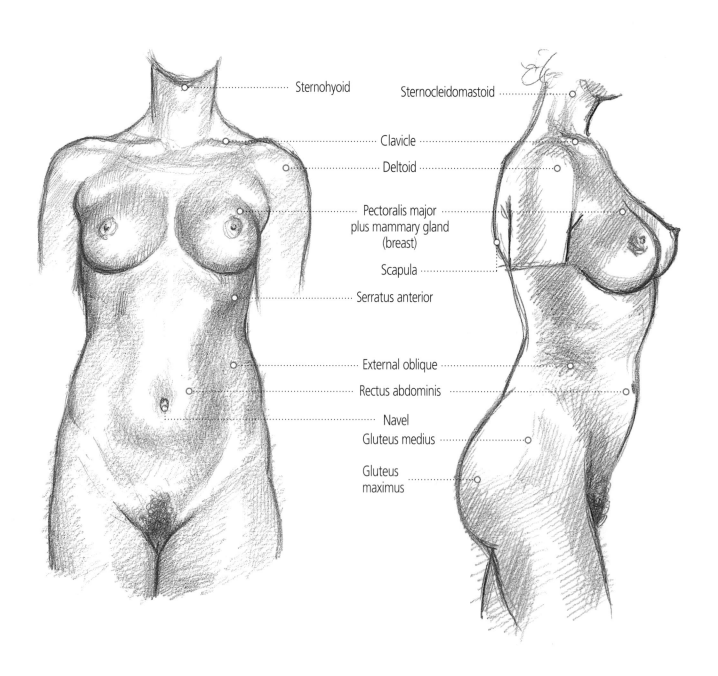

Sternohyoid

Sternocleidomastoid

Clavicle

Deltoid

Pectoralis major
plus mammary gland
(breast)

Scapula

Serratus anterior

External oblique

Rectus abdominis

Navel

Gluteus medius

Gluteus
maximus

## SURFACE OF THE FEMALE TORSO
### BACK VIEW

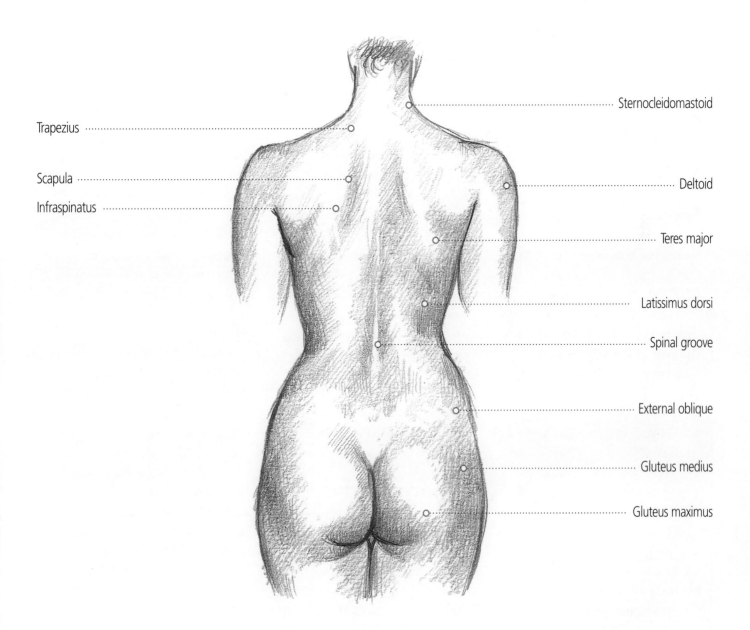

Trapezius

Scapula

Infraspinatus

Sternocleidomastoid

Deltoid

Teres major

Latissimus dorsi

Spinal groove

External oblique

Gluteus medius

Gluteus maximus

# MUSCLES AND BONES OF THE TORSO

Because so much of the skeleton is hidden, it may be difficult to differentiate between muscle and bone. However, listed below are the bones that are visible on most bodies of average build. There may be some people with more developed areas of fatty deposit that disguise the less obvious ones, but usually the following bones can be seen:

• Clavicle
• Sternum
• Parts of the scapula

• Seven cervical vertebrae
• First and twelfth thoracic vertebrae, in certain positions

• First and twelfth ribs
• Pubis
• Iliac crest
• Iliac tuberosity
• Anterior superior iliac spine

For an artist, recognizing these bony points on the surface of the body is very useful, since they make good measuring points. Unlike the muscles and fatty parts, they do not move. Look out too for the suprasternal notch: this is the space

---

ABDOMINAL MUSCLES flex torso forwards into curled position, straightening arch of lumbar vertebrae. Compress viscera to force expiration, or strain in childbirth and defecation. The three layers create strong walls on either side of the abdomen.

DELTOID contraction of entire muscle will raise arm to horizontal plane. Partial contraction will result in pulling the arm backwards or forwards.

ERECTOR SPINAE GROUP made up of the LONGISSIMUS, the SPINALIS and the ILIO-COSTALIS. Lift torso when rising from stooped position. Straighten spine, extend spine backwards or to either side. Draw pelvis backwards and upwards. Help support the weight of the head. Sometimes referred to as the Sacrospinalis.

INFRASPINATUS rotates arm outwards and backwards.

INTERNAL and EXTERNAL OBLIQUE flex trunk. Isolated action of one side turns anterior surface of trunk to that side. Bends spinal column laterally. Co-operates

with the other abdominal muscles. Simultaneous contraction of muscles of both sides results in forward bending of trunk. If chest is fixed, pelvis is brought into flexion. Constricts abdominal cavity, ribs are compressed and pulled downwards.

LATISSIMUS DORSI throws back shoulders. Draws arm backwards and towards the centre line. Rotates it inwards and lowers it. If shoulders are fixed, it raises trunk and suspends it.

LEVATOR SCAPULAE steadies scapula during movements of the arms.

PECTORALIS MAJOR draws arm forwards, rotates it inwards and lowers arm.

QUADRATUS LUMBORUM holds firm the twelfth rib and pulls lumbar region of the spine to its own side and helps straighten or raise pelvis.

RECTUS ABDOMINIS flexes trunk.

RHOMBOIDS MAJOR and MINOR elevate, rotate scapula. Draw it towards the median line.

SEMISPINALIS CAPITIS two deep neck muscles beneath trapezius, where they help to draw head backwards or rotate it to either side.

SERRATUS ANTERIOR draws scapula forwards and laterally. Helps trapezius in raising the arm above the horizontal plane.

SERRATUS POSTERIOR MUSCLE S steady the erector spinae group. Superior pair elevate upper ribs, helping us to breathe in. Inferior pair are expiratory, depressing lower ribs as we breathe out.

SPLENIUS CAPITIS pulls head backwards and sideways; rotates it.

SPLENIUS CERVICIS pulls neck backwards and sideways, rotates atlas (top vertebra) along with head.

SUBCLAVIUS fixes and pulls clavicle downwards and forwards.

SUBSCAPULARIS (beneath scapula) rotates arm inwards.

SUPRASPINATUS raises and rotates arm outwards.

TERES MAJOR raises arm forwards or sideways from trunk. Rotates arm inwards.

TERES MINOR rotates arm outwards.

TRAPEZIUS extends head, inclines it to one side and turns head in opposite direction. Middle part lifts scapula. Inferior part lowers scapula.

# MUSCLES AND BONES OF THE TORSO

between the two clavicles where they meet the manubrium or the upper part of the sternum (breast bone). It is a useful marker for measuring the head and shoulders because it remains at a fixed point at the base of the neck. The notch is visible on the vast majority of humans.

There are more than a hundred muscles in the torso, and they tend to be paired on either side of the body's medial line, and layered in groups. A series of divided muscles

support and articulate the spine. There are broad, thin sheets of muscle enfolding the abdomen and the pelvis. Thick, heavy muscles give strength to the shoulders and hips. The diagonally arranged muscles of the ribcage help with breathing and the flexibility of the upper torso.

On the opposite page, I have detailed the major muscles of the torso and some of the movements they produce by contracting or flexing. Try performing some of these movements and feeling your own muscles at work.

## FRONT VIEW

First we show the relaxed torso, in order to relate the muscles to the bone structure.

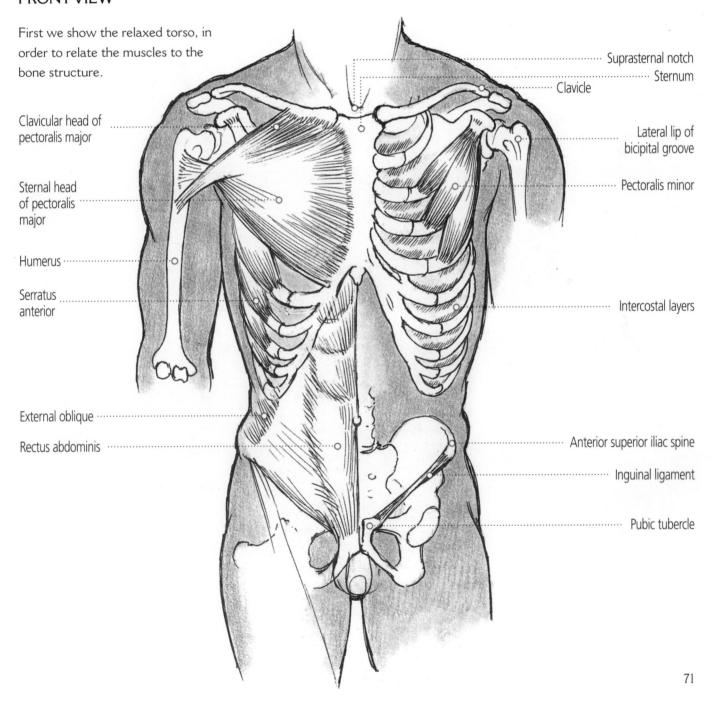

Clavicular head of pectoralis major

Sternal head of pectoralis major

Humerus

Serratus anterior

External oblique

Rectus abdominis

Suprasternal notch

Sternum

Clavicle

Lateral lip of bicipital groove

Pectoralis minor

Intercostal layers

Anterior superior iliac spine

Inguinal ligament

Pubic tubercle

# SURFACE VIEWS OF THE MOVING TORSO

## FRONT VIEW OF MALE TORSO WITH ARMS RAISED

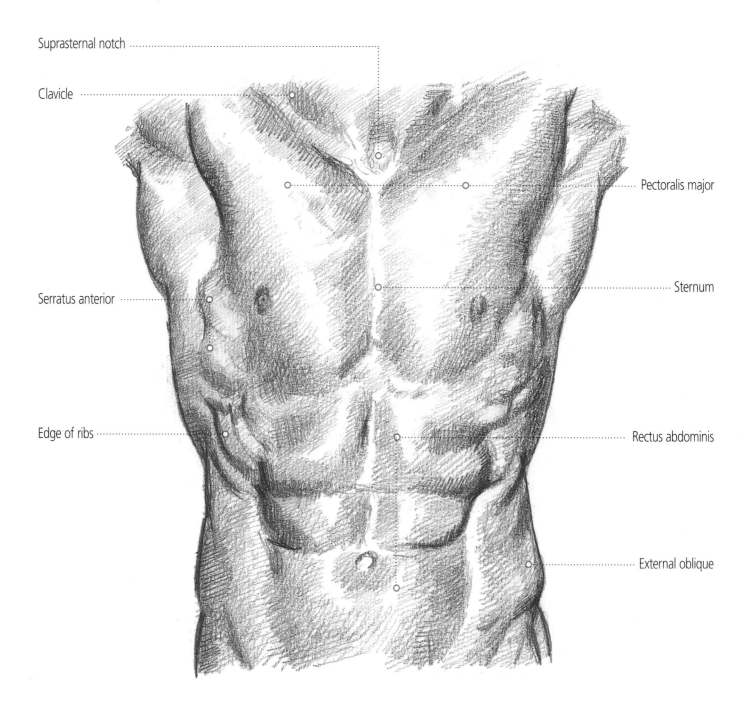

Suprasternal notch

Clavicle

Serratus anterior

Edge of ribs

Pectoralis major

Sternum

Rectus abdominis

External oblique

# SURFACE VIEWS OF THE MOVING TORSO

## SIDE VIEW WITH ARMS RAISED

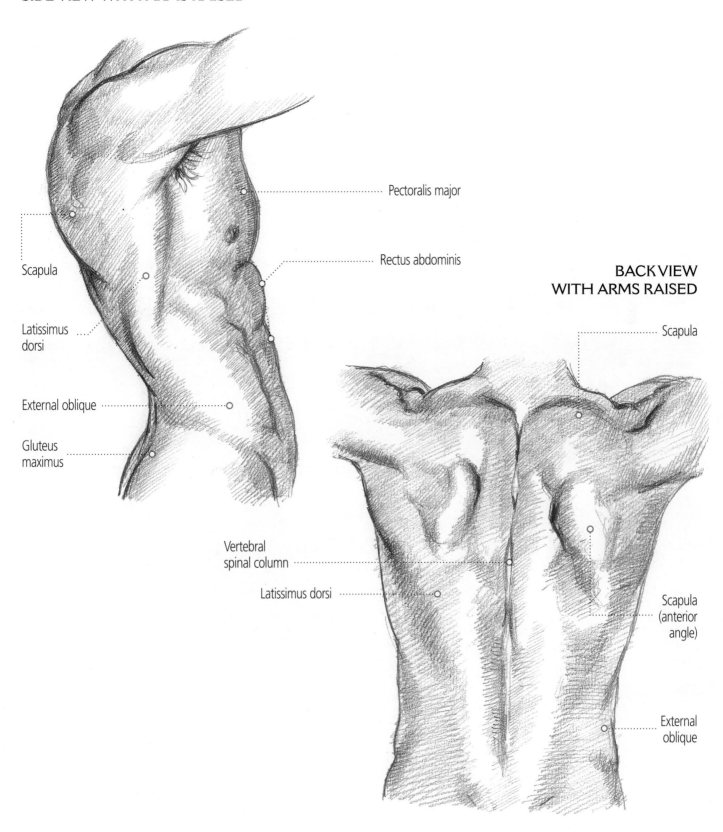

Pectoralis major

Rectus abdominis

Scapula

Latissimus
dorsi

External oblique

Gluteus
maximus

## BACK VIEW
## WITH ARMS RAISED

Scapula

Vertebral
spinal column

Latissimus dorsi

Scapula
(anterior
angle)

External
oblique

## SURFACE VIEWS OF THE MOVING TORSO

THE MALE TORSO, STRETCHED
BACKWARDS, ARMS RAISED

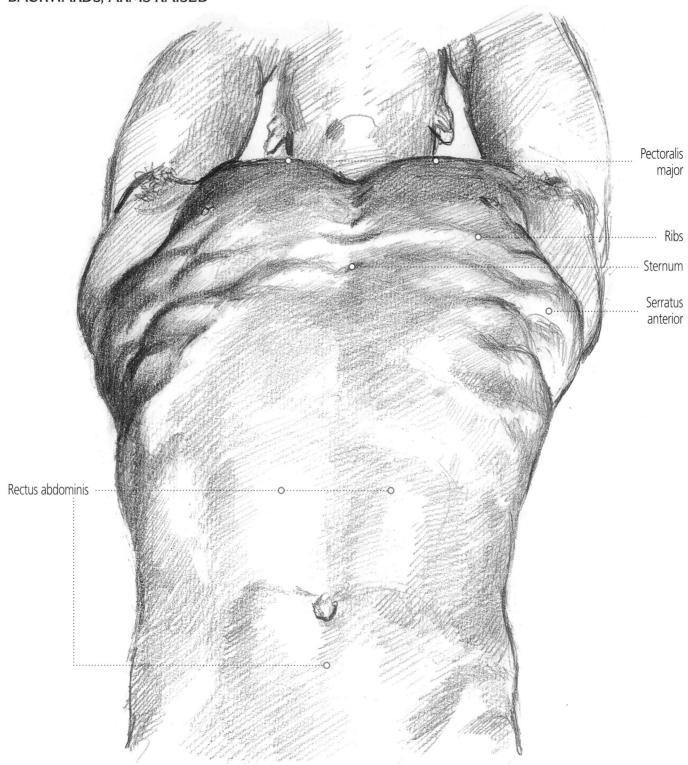

Pectoralis major

Ribs

Sternum

Serratus anterior

Rectus abdominis

## SURFACE VIEWS OF THE MOVING TORSO

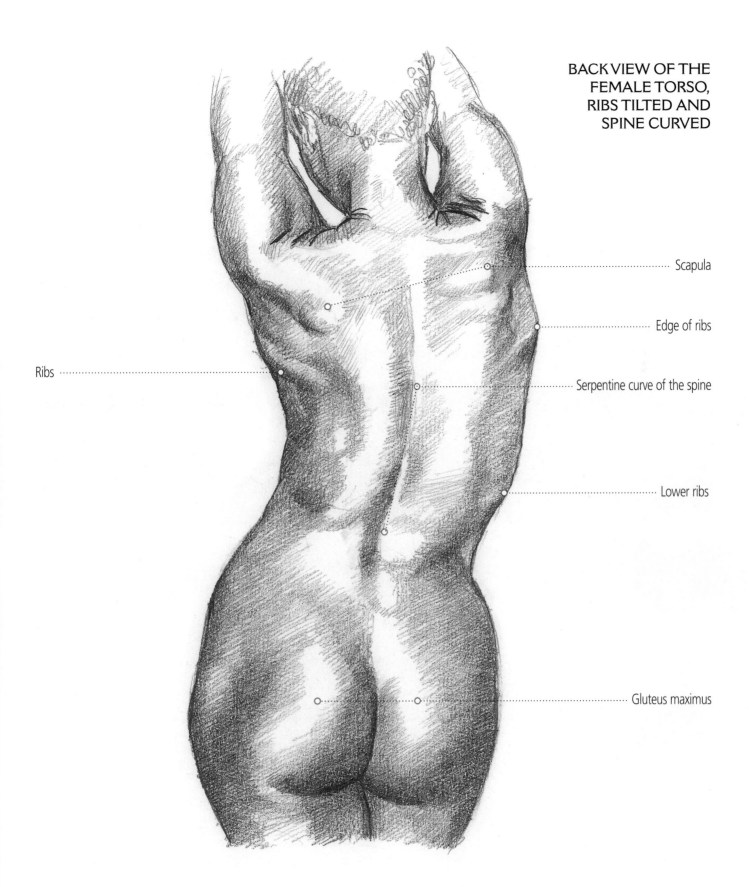

BACK VIEW OF THE
FEMALE TORSO,
RIBS TILTED AND
SPINE CURVED

Scapula

Edge of ribs

Ribs

Serpentine curve of the spine

Lower ribs

Gluteus maximus

# The Arms & Hands

The upper limbs of the body are structured on the basis of the long bones of the humerus, the ulna and the radius, with the additional small bones of the wrist and hand. The design of the arm is very subtle and the hand so flexible and adaptable that almost any movement in any direction is possible. These are the limbs that allow human beings to handle tools, operate machines and do the things that most other animals cannot manage.

The way that the arms work from the shoulders is quite complex and so too is the musculature of the hand; don't be surprised if you find it difficult to retain all the anatomical information.

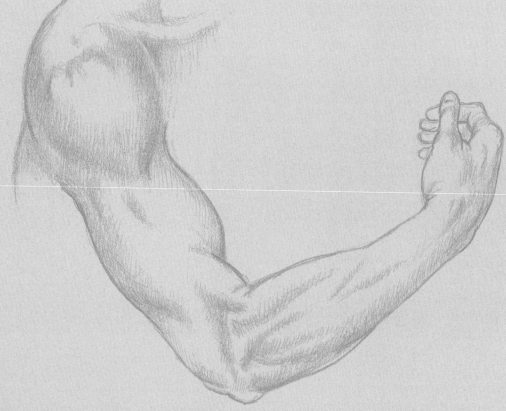

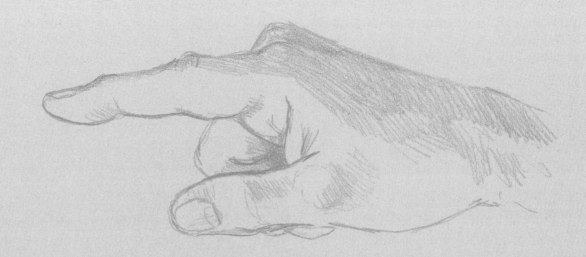

However, as an artist, your main goal is to gain familiarity with the general structure of the arms and hands, so that when you come to draw them, they will be convincing enough to give your drawing some credibility.

As in previous sections of this book, I will first give an outline of the skeleton, then the muscles that surround the bone structure, followed by the surface view of the limb and a range of arm and hand movements.

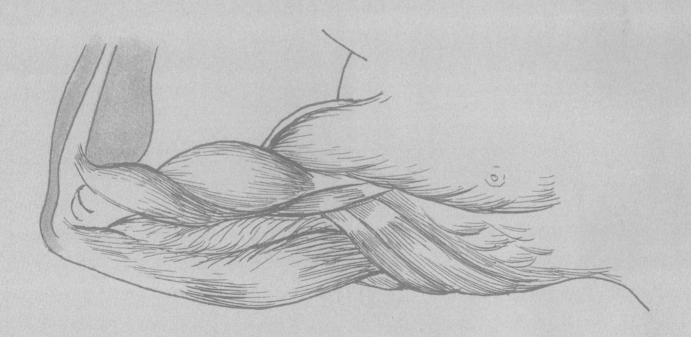

## SKELETON OF THE ARM AND HAND
### FRONT VIEW

The bone structure of the arm appears quite straight-forward at first glance. However, the areas of the shoulder and the wrist are quite complex and help to allow the many movements of the limb.

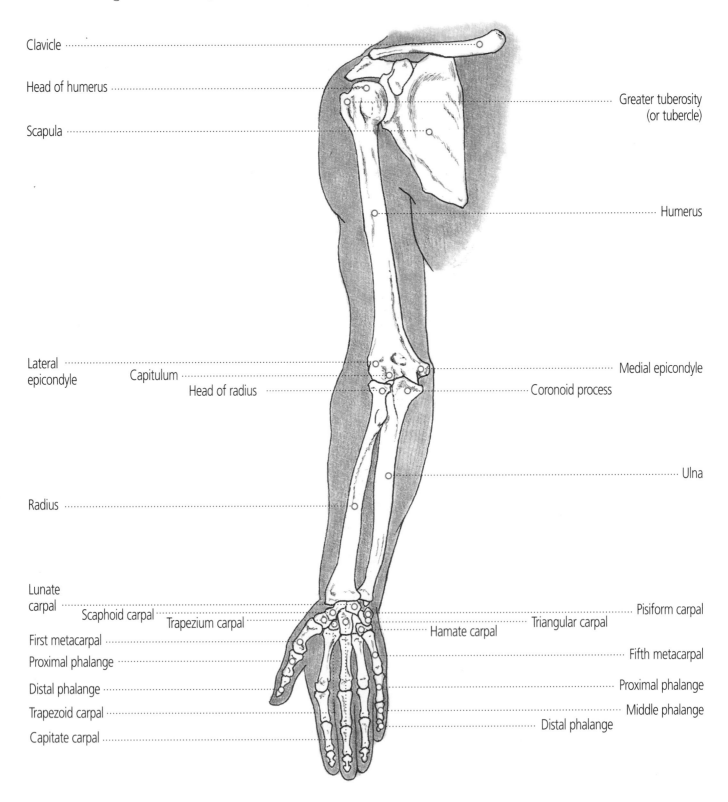

Clavicle

Head of humerus

Scapula

Lateral epicondyle

Capitulum

Head of radius

Radius

Lunate carpal

Scaphoid carpal

Trapezium carpal

First metacarpal

Proximal phalange

Distal phalange

Trapezoid carpal

Capitate carpal

Greater tuberosity (or tubercle)

Humerus

Medial epicondyle

Coronoid process

Ulna

Pisiform carpal

Triangular carpal

Hamate carpal

Fifth metacarpal

Proximal phalange

Middle phalange

Distal phalange

## SKELETON OF THE ARM AND HAND
### BACK VIEW

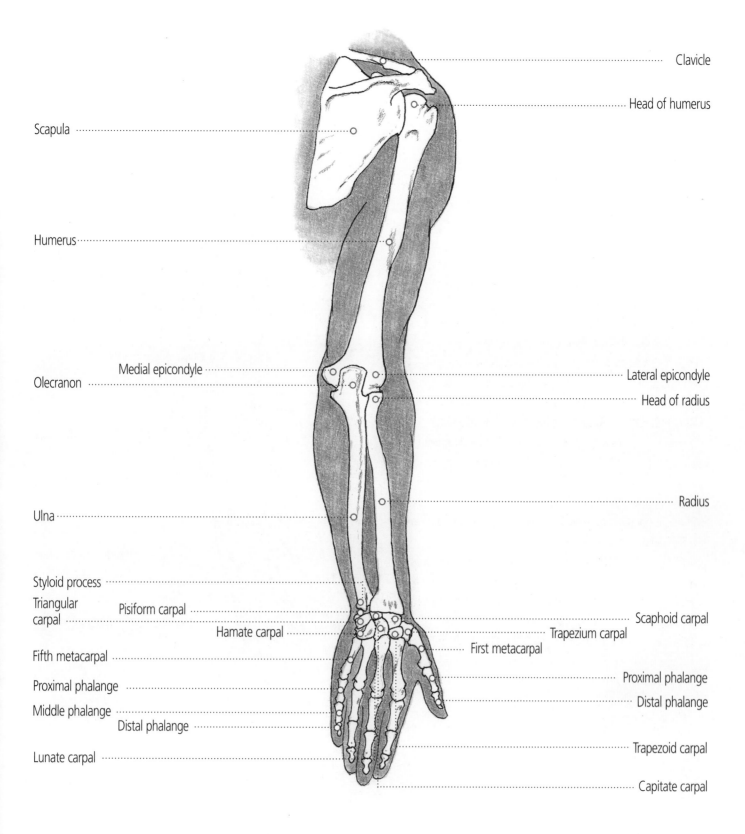

Clavicle

Head of humerus

Scapula

Humerus

Medial epicondyle

Olecranon

Lateral epicondyle

Head of radius

Radius

Ulna

Styloid process

Triangular carpal

Pisiform carpal

Hamate carpal

Scaphoid carpal

Trapezium carpal

First metacarpal

Fifth metacarpal

Proximal phalange

Proximal phalange

Distal phalange

Middle phalange

Distal phalange

Lunate carpal

Trapezoid carpal

Capitate carpal

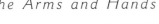
# THE UPPER ARM AND SHOULDER IN DETAIL
## MUSCLE AND BONE STRUCTURE

Because of the complex attachment of the arm to the torso via the shoulder, we now examine it in some depth. These diagrams show how the muscles are linked to the bone structure and how they all show on the surface of the arm.

**FRONT VIEW**

BICEPS BRACHII flexes elbow joint and supinates forearm.

BRACHIALIS flexes forearm.

CORACOBRACHIALIS flexes and adducts shoulder.

DELTOID pulls limb forwards when arm is raised level with shoulder. Raises and holds arm horizontal, and draws limb backwards when horizontal.

INFRASPINATUS and TERES MINOR help to rotate arm backwards.

LATISSIMUS DORSI powerfully draws the arm backwards.

PECTORALIS MAJOR extends arm and draws it across the front of the torso.

PECTORALIS MINOR holds scapula against ribcage and raises ribs during forced breathing. It also pulls shoulder down and forwards.

RHOMBOIDS MAJOR AND MINOR (beneath trapezius) draw scapula towards the median line.

SERRATUS ANTERIOR pulls shoulder forward and gives force to punch. Prevents shoulder blade from swinging to side.

SUBCLAVIUS fixes and pulls clavicle downwards and forwards.

SUBSCAPULARIS (beneath scapula) rotates arm inward.

SUPRASPINATUS raises and rotates arm outwards.

TERES MAJOR with LATISSIMUS DORSI extends, adducts and rotates arm inwards.

TENDON AND APONEUROSIS OF TRICEPS flatten back of arm above elbow.

TRAPEZIUS raises and lowers shoulders and draws head to either side.

TRICEPS BRACHII extends limb.

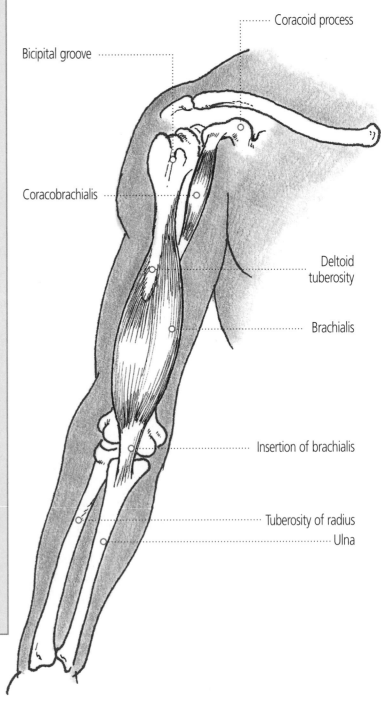

Bicipital groove

Coracoid process

Coracobrachialis

Deltoid tuberosity

Brachialis

Insertion of brachialis

Tuberosity of radius

Ulna

# THE UPPER ARM AND SHOULDER IN DETAIL
## MUSCLE AND BONE STRUCTURE

**SIDE VIEW**

Deltoid

**FRONT VIEW SHOWING RIBS**

Clavicle

Subclavius

Pectoralis minor
(under pectoralis major)

Scapula

Humerus

Ribs

**FROM ABOVE**

Septa area

Acromion

Anterior border of deltoid

**FRONT VIEW WITHOUT RIBS**

Clavicle

Subscapularis

Teres major

Scapula

Humerus

**BACK VIEW**

Posterior part of deltoid contracting

Vertebral border of retracted scapula

## THE UPPER ARM AND SHOULDER IN DETAIL
MUSCLE AND BONE STRUCTURE

Note how these muscles fit underneath and overlay one another, forming a strong mass that enables the arm to move easily in any direction without damage. All the muscles affect one another when flexing or contracting, which translates as a 'rippling' effect on the surface of the arm. This is particularly visible in athletes and weightlifters.

FRONT VIEW

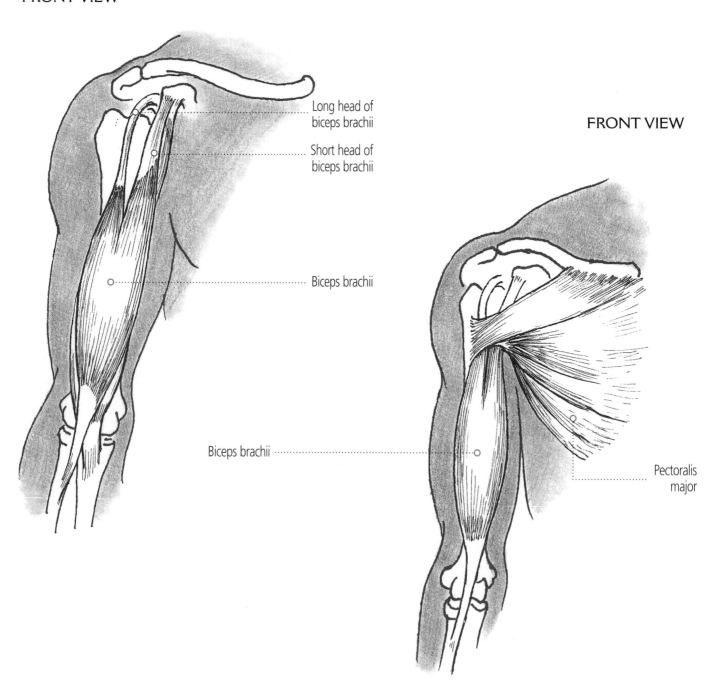

Long head of biceps brachii

Short head of biceps brachii

Biceps brachii

FRONT VIEW

Biceps brachii

Pectoralis major

# THE UPPER ARM AND SHOULDER IN DETAIL
## MUSCLE AND BONE STRUCTURE

**BACK VIEW**

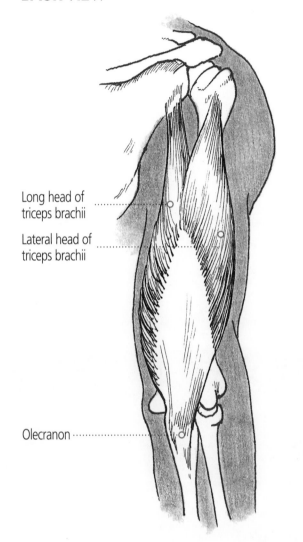

Long head of
triceps brachii

Lateral head of
triceps brachii

Olecranon

**BACK VIEW**

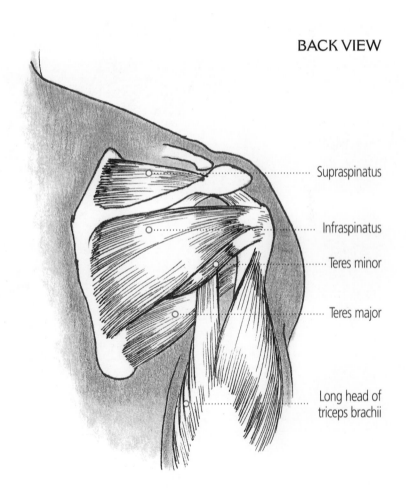

Supraspinatus

Infraspinatus

Teres minor

Teres major

Long head of
triceps brachii

## THE UPPER ARM IN MOVEMENT
LIFTING

FRONT VIEW

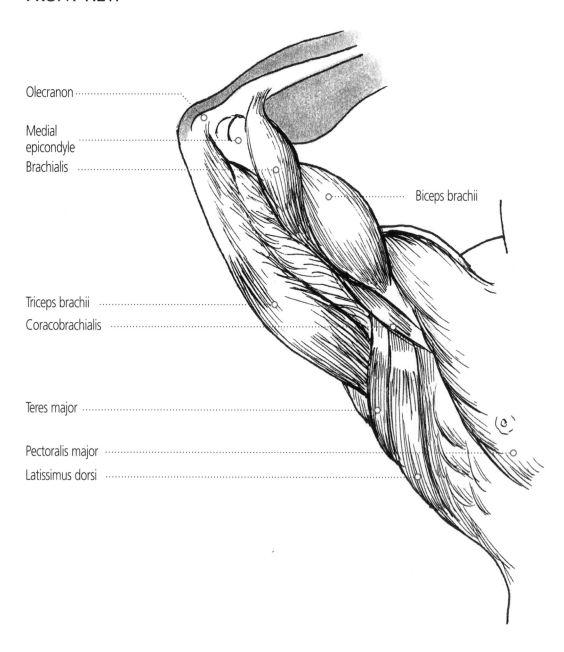

Olecranon

Medial
epicondyle

Brachialis

Biceps brachii

Triceps brachii

Coracobrachialis

Teres major

Pectoralis major

Latissimus dorsi

# THE UPPER ARM IN MOVEMENT
## FLEXING

**FRONT VIEW**

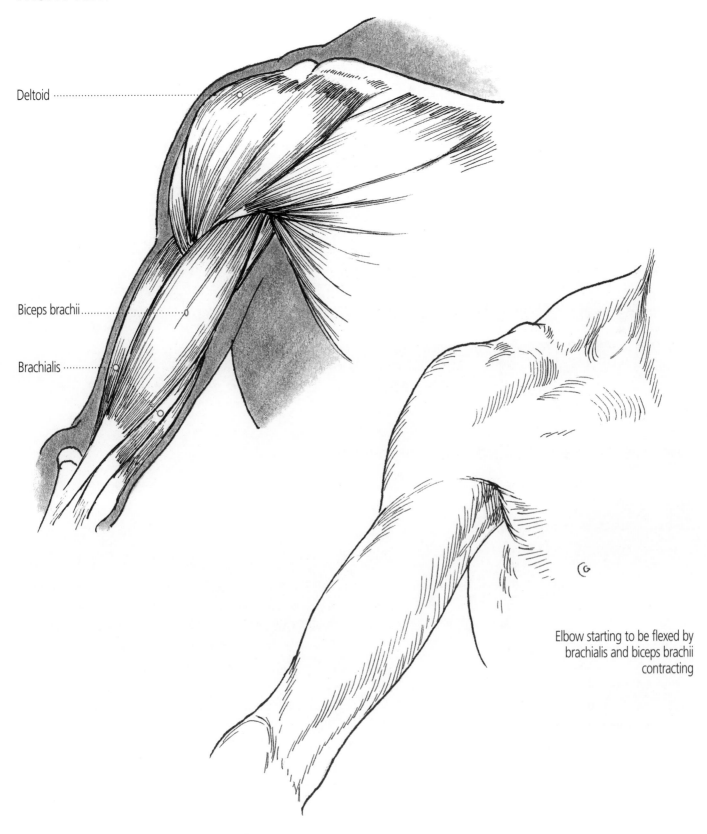

Deltoid

Biceps brachii

Brachialis

Elbow starting to be flexed by brachialis and biceps brachii contracting

# MUSCLES OF THE LOWER ARM AND HAND

## THE MUSCLES OF THE LOWER ARM AND HOW THEY WORK

ABDUCTOR POLLICIS LONGUS extends and abducts the thumb.

ANCONEUS extends forearm.

BRACHIORADIALIS flexes elbow joint.

LONG EXTENSOR MUSCLES on posterior forearm pass into the back of hand.

EXTENSOR DIGITORUM extends fingers (not thumb);

EXTENSOR DIGITI MINIMI extends little finger.

EXTENSOR CARPI ULNARIS extends wrist, adducts hand.

EXTENSOR POLLICIS BREVIS extends proximal phalanx of thumb.

EXTENSOR INDICIS extends forefinger.

EXTENSOR CARPI RADIALIS BREVIS extends the hand at the wrist.

EXTENSOR CARPI RADIALIS LONGUS extends wrist on side of radius.

EXTENSOR POLLICIS LONGUS extends the thumb.

FLEXOR CARPI RADIALIS flexes and rotates hand inwards.

FLEXOR CARPI ULNARIS flexes wrist on side of ulna.

FLEXOR DIGITI MINIMI BREVIS flexes little finger.

FLEXOR DIGITORUM PROFUNDUS flexes middle and distal phalanges of fingers (not thumb).

FLEXOR DIGITORUM SUPERFICIALIS flexes middle and distal phalanges of fingers (not thumb) and wrist.

FLEXOR POLLICIS LONGUS flexes distal phalanx.

PALMARIS LONGUS the weakest, least significant muscle, sometimes missing in one forearm, flexes hand.

PRONATOR QUADRATUS causes pronation of radius.

PRONATOR TERES causes pronation of forearm, helps in flexion of forearm.

SUPINATOR the shortest extensor, rotates radius outwards on its own axis.

## THE MUSCLES OF THE HAND AND HOW THEY WORK

*Note that there are no muscles in the fingers, only bones and tendons tied by fibrous bands. The small fatty pads on the ends of fingers carry blood and nerves and cushion flexor tendons.*

ABDUCTOR DIGITI MINIMI moves little finger outwards.

ABDUCTOR POLLICIS BREVIS draws thumb forwards at a right angle to palm.

ADDUCTOR POLLICIS draws thumb towards palm.

DORSAL INTEROSSEI abduct fingers from midline of hand.

FLEXOR and EXTENSOR RETINACULA enable tendons of hand to change direction at wrist.

FLEXOR POLLICIS BREVIS flexes proximal phalanx of thumb.

LUMBRICALES flex the proximal and extend the middle and distal phalanges.

OPPONENS DIGITI MINIMI draws fifth metacarpal forwards and inwards, to hollow the palm.

OPPONENS POLLICIS allows opposition of thumb.

PALMAR MUSCLES lie beneath palmar aponeurosis (thickened fascia), holding skin to muscles and bones below.

PALMAR INTEROSSEI move fingers inwards to midline of hand.

# MUSCLES OF THE LOWER ARM
## PALM-UP VIEW

Here are four views of the lower arm, palm up, showing the layers of muscle from deepest (1) to most superficial (4).

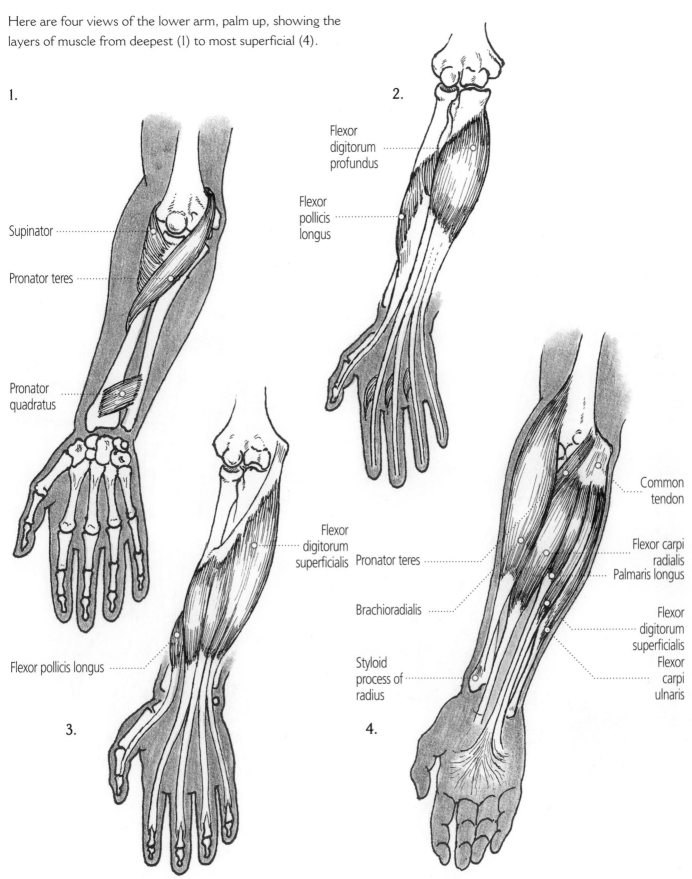

1.

Supinator

Pronator teres

Pronator quadratus

Flexor pollicis longus

3.

2.

Flexor digitorum profundus

Flexor pollicis longus

Flexor digitorum superficialis

Pronator teres

Brachioradialis

Styloid process of radius

Common tendon

Flexor carpi radialis

Palmaris longus

Flexor digitorum superficialis

Flexor carpi ulnaris

4.

## MUSCLES OF THE LOWER ARM
### PALM-DOWN VIEW

DEEP LEVEL

SUPERFICIAL LEVEL

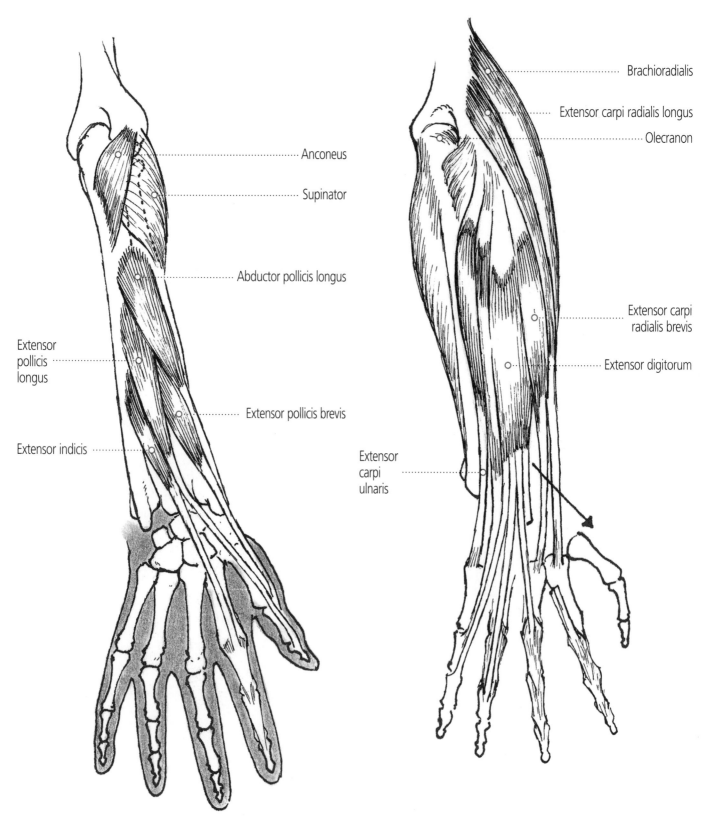

Anconeus

Supinator

Abductor pollicis longus

Extensor
pollicis
longus

Extensor pollicis brevis

Extensor indicis

Brachioradialis

Extensor carpi radialis longus

Olecranon

Extensor carpi
radialis brevis

Extensor digitorum

Extensor
carpi
ulnaris

# MUSCLES OF THE LOWER ARM AND HAND

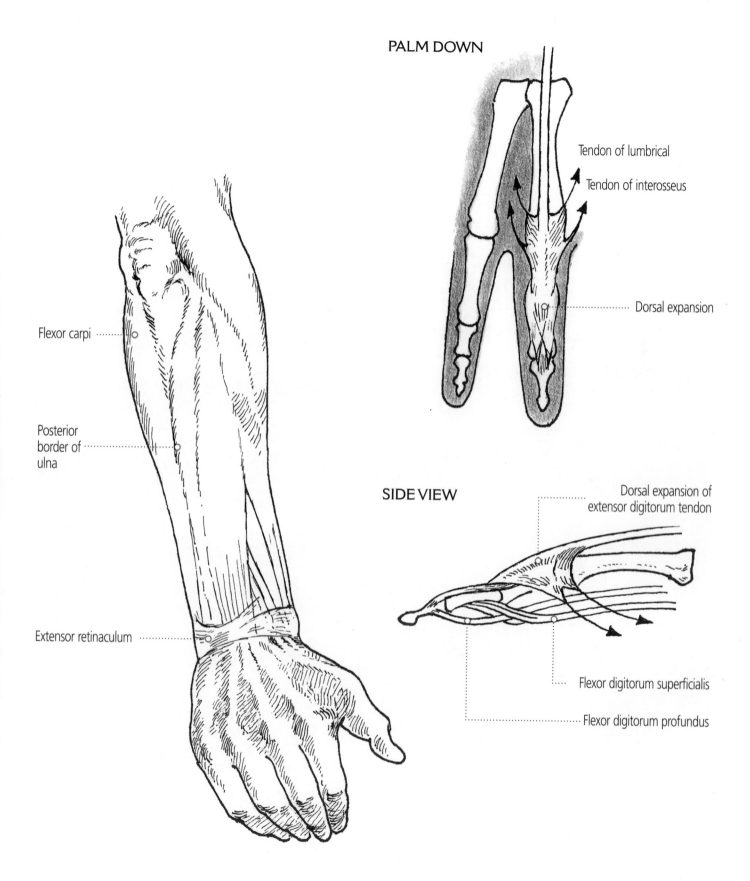

**PALM DOWN**

Tendon of lumbrical

Tendon of interosseus

Dorsal expansion

Flexor carpi

Posterior border of ulna

Extensor retinaculum

**SIDE VIEW**

Dorsal expansion of extensor digitorum tendon

Flexor digitorum superficialis

Flexor digitorum profundus

## SURFACE OF THE MALE ARM AND HAND
### PALM-UP AND PALM-DOWN VIEW

When the arm is stretched out horizontally, we can see the shapes of the larger muscles at the surface of the limb. Here we look at the outstretched arm from two angles:

with the palm facing up (supine view) and with the palm facing down (prone view).

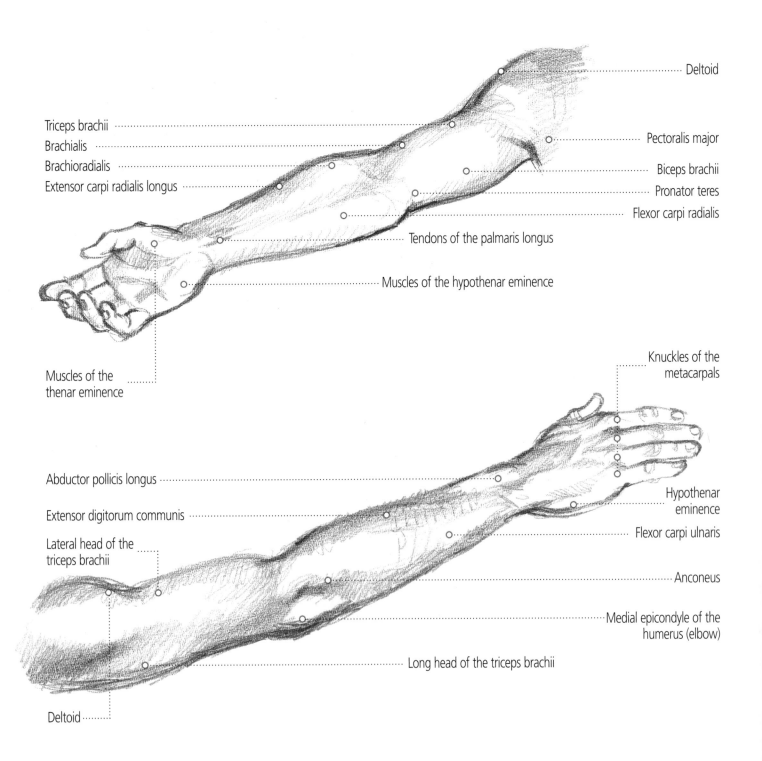

Deltoid

Triceps brachii

Brachialis

Brachioradialis

Extensor carpi radialis longus

Pectoralis major

Biceps brachii

Pronator teres

Flexor carpi radialis

Tendons of the palmaris longus

Muscles of the hypothenar eminence

Muscles of the thenar eminence

Knuckles of the metacarpals

Abductor pollicis longus

Extensor digitorum communis

Lateral head of the triceps brachii

Hypothenar eminence

Flexor carpi ulnaris

Anconeus

Medial epicondyle of the humerus (elbow)

Long head of the triceps brachii

Deltoid

## SURFACE OF THE FEMALE ARM AND HAND
### PALM-UP AND PALM-DOWN VIEW

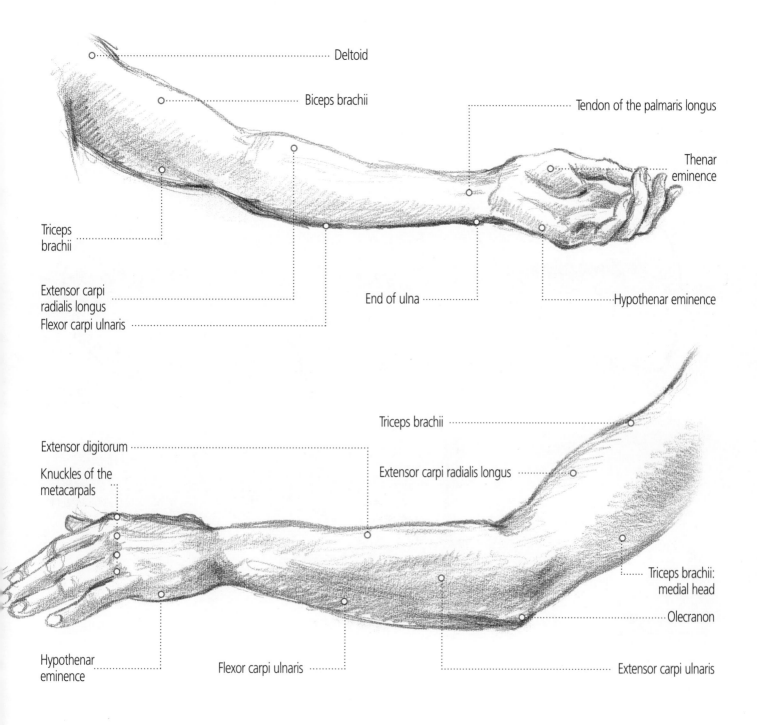

Deltoid

Biceps brachii

Tendon of the palmaris longus

Thenar eminence

Triceps brachii

Extensor carpi radialis longus

Flexor carpi ulnaris

End of ulna

Hypothenar eminence

Triceps brachii

Extensor digitorum

Extensor carpi radialis longus

Knuckles of the metacarpals

Triceps brachii: medial head

Olecranon

Hypothenar eminence

Flexor carpi ulnaris

Extensor carpi ulnaris

91

## THE ARM IN MOVEMENT
### PIVOTING FOREARM

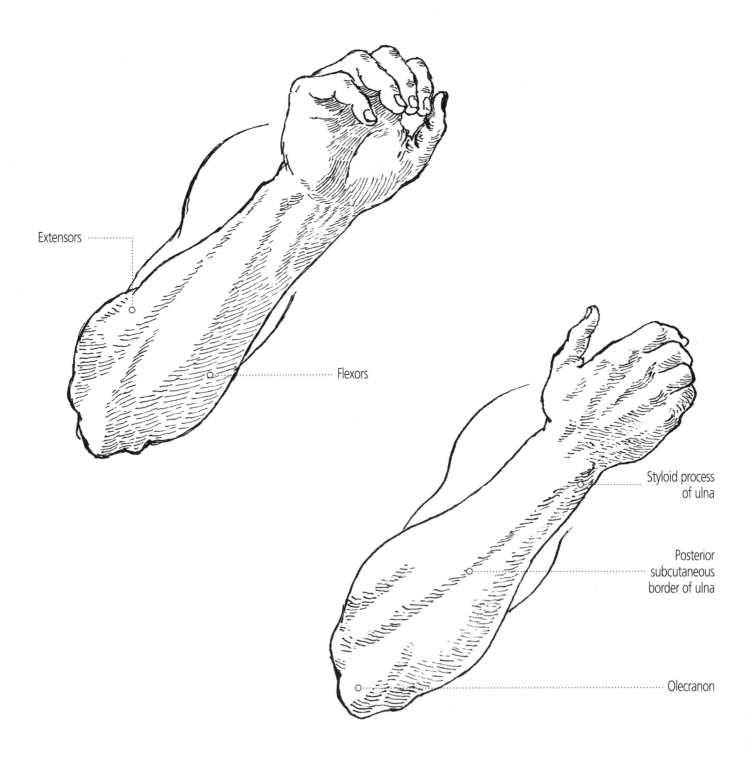

Extensors

Flexors

Styloid process of ulna

Posterior subcutaneous border of ulna

Olecranon

## THE ARM IN MOVEMENT
### FLEXING WHOLE ARM

**FLEXED ARM**

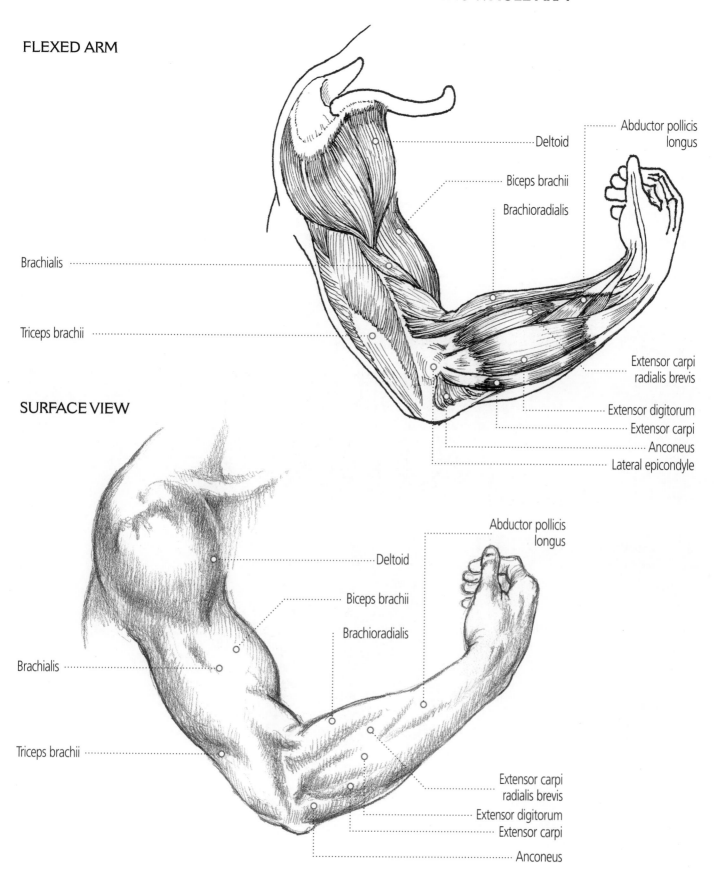

Deltoid

Abductor pollicis
longus

Biceps brachii

Brachioradialis

Brachialis

Triceps brachii

Extensor carpi
radialis brevis

Extensor digitorum

Extensor carpi

Anconeus

Lateral epicondyle

**SURFACE VIEW**

Abductor pollicis
longus

Deltoid

Biceps brachii

Brachioradialis

Brachialis

Triceps brachii

Extensor carpi
radialis brevis

Extensor digitorum

Extensor carpi

Anconeus

## SKELETON OF THE HAND
### PALM-DOWN VIEW

As well as combined drawings of the arm and hand, I am also dealing with the hand separately because it is such an intricate part of the upper limb. These diagrams of the

bones of the hand seen from four different angles are well worth studying, so you will be able to recognize them through the covering of muscle and skin.

**UPPER ROW OF CARPALS (WRIST BONES)**

**LOWER ROW OF CARPALS (WRIST BONES)**

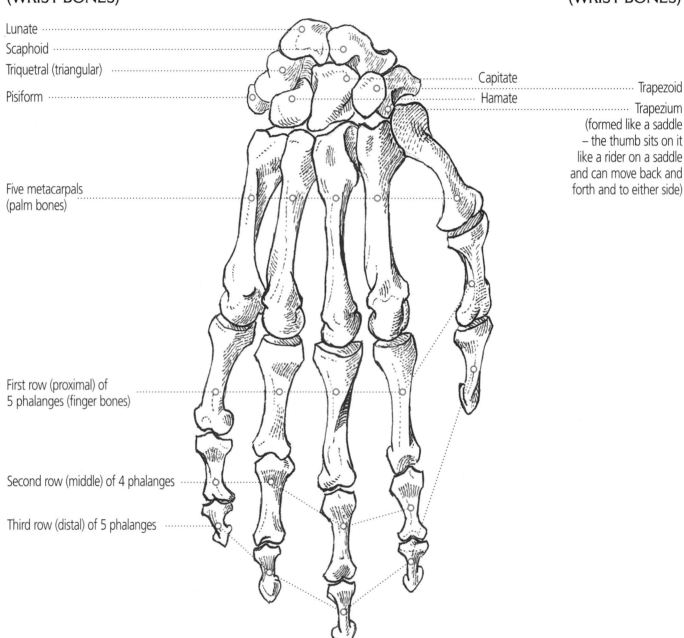

Lunate

Scaphoid

Triquetral (triangular)

Pisiform

Capitate

Hamate

Trapezoid

Trapezium
(formed like a saddle
– the thumb sits on it
like a rider on a saddle
and can move back and
forth and to either side)

Five metacarpals
(palm bones)

First row (proximal) of
5 phalanges (finger bones)

Second row (middle) of 4 phalanges

Third row (distal) of 5 phalanges

- Carpals (wrist bones)

- Metacarpals (palm bones)

- Phalanges (finger bones)

## SKELETON OF THE HAND
### PALM-UP VIEW

LOWER ROW OF CARPALS
(WRIST BONES)

UPPER ROW OF CARPALS
(WRIST BONES)

Scaphoid

Lunate

Trapezium

Capitate

Triquetral (triangular)

Trapezoid

Pisiform

Hamate

Five metacarpals (palm
bones)

First row (proximal) of 5
phalanges (finger bones)

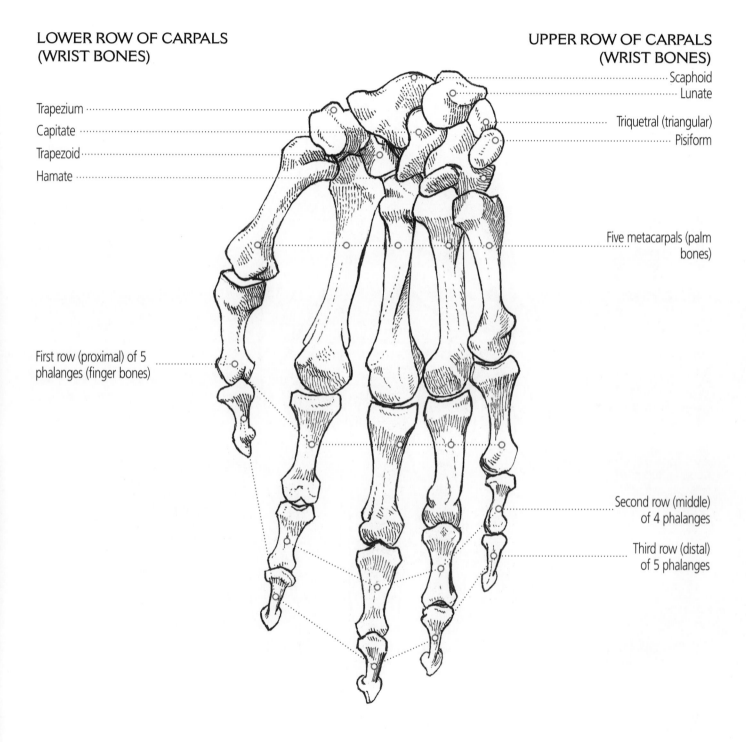

Second row (middle)
of 4 phalanges

Third row (distal)
of 5 phalanges

## MUSCLES OF THE HAND
### PALM-UP VIEW

The hand, the part of the body which sets human skills apart from all the other animals, is a very complex structure of overlapping muscles and tendons. These allow the fingers and thumb to perform very complicated and subtle motions, enabling humans to construct and handle an enormous number of tools (like the pencil), extending their range of activities far beyond other species.

The main difficulty in drawing the muscles of the hand is

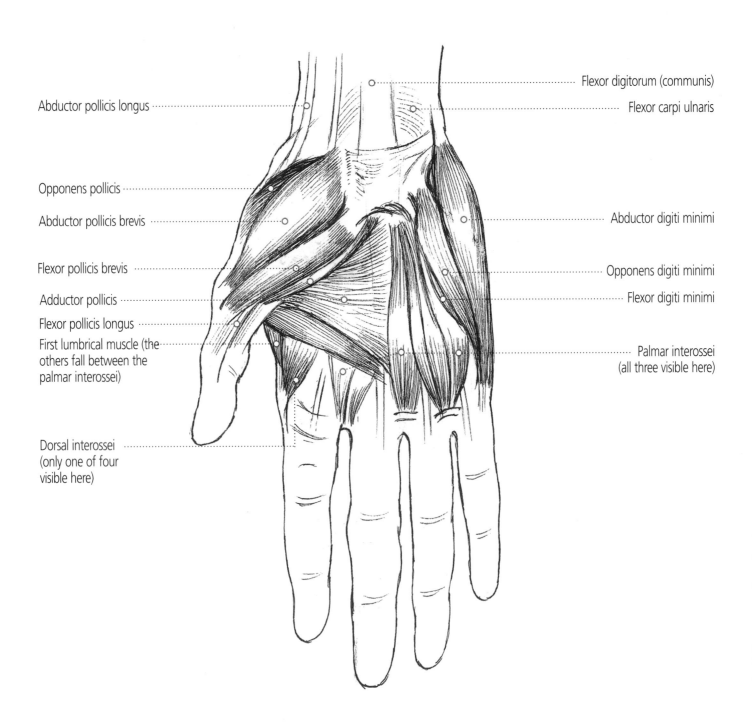

Abductor pollicis longus

Opponens pollicis

Abductor pollicis brevis

Flexor pollicis brevis

Adductor pollicis

Flexor pollicis longus

First lumbrical muscle (the others fall between the palmar interossei)

Dorsal interossei (only one of four visible here)

Flexor digitorum (communis)

Flexor carpi ulnaris

Abductor digiti minimi

Opponens digiti minimi

Flexor digiti minimi

Palmar interossei (all three visible here)

## MUSCLES OF THE HAND
### PALM-DOWN VIEW

that the most significant ones are situated in the arm and are connected to the hand by long tendons. There are some muscles in the hand itself, but they tend to be hidden under the surface pads of the palm and so are not very evident.

The most clearly seen muscles are around the base of the thumb and on the opposite edge of the palm.

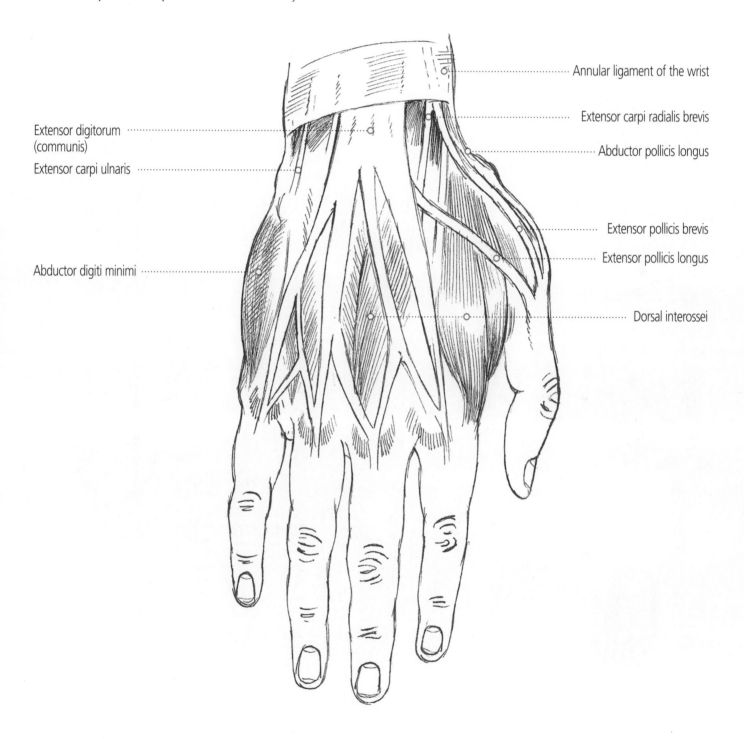

Extensor digitorum (communis)

Extensor carpi ulnaris

Abductor digiti minimi

Annular ligament of the wrist

Extensor carpi radialis brevis

Abductor pollicis longus

Extensor pollicis brevis

Extensor pollicis longus

Dorsal interossei

97

# RANGE OF HAND MOVEMENT

It is well worth studying the hand in detail, as its movements can be very expressive and capturing them accurately will add a lot to your drawing.

The movements of the hand are mainly produced higher up the arm, the hand itself only having a few muscles. When you move your hand, notice the movements in the muscles of your forearm or upper arm where the action originates.

Look out for details, like the pads on the palm of the hand and the front of the fingers which push out when the hand is closed into a fist.

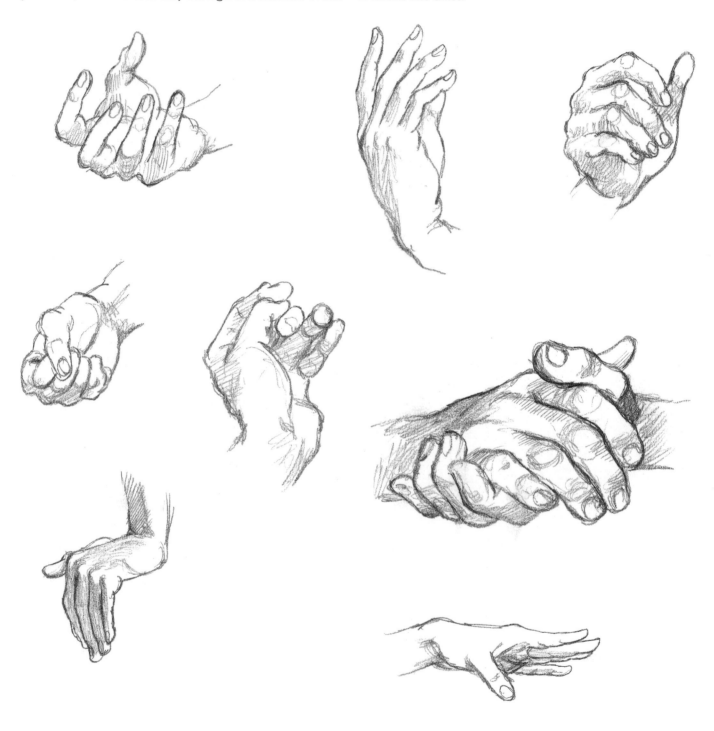

## RANGE OF HAND MOVEMENT

MORE PRECISE HAND MOVEMENTS

HOLDING A
PENCIL

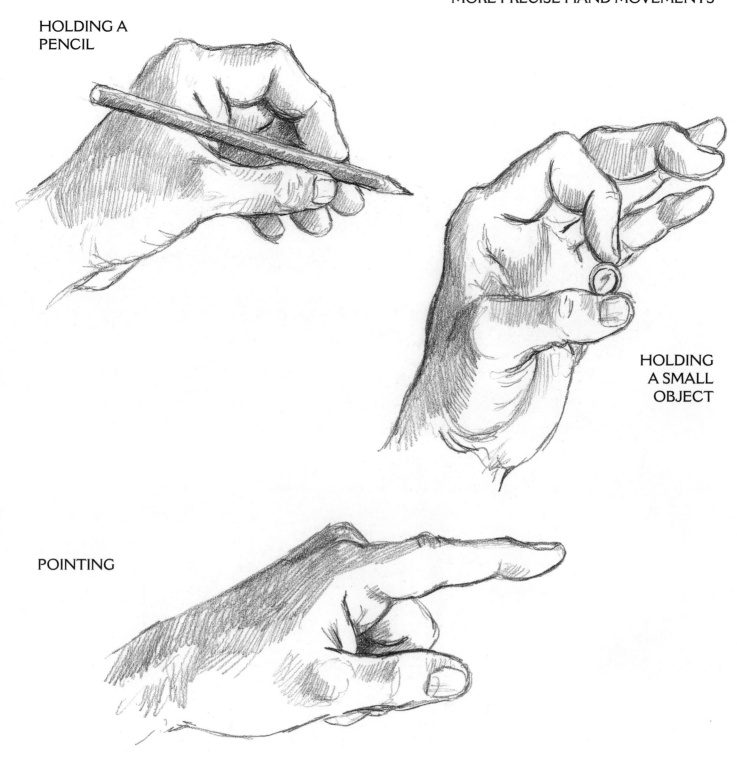

HOLDING
A SMALL
OBJECT

POINTING

# The Legs & Feet

Our lower limbs are probably the most powerful parts of the body, having the largest bones and the strongest muscles. This is no surprise, since the legs not only support the total body weight, but also have to propel it along in the world.

The hingeing of the legs on to the torso is very strongly supported, both in the shape and construction of the skeletal structure, and in the completeness of the muscle system that holds it all together and allows it to move. Legs and feet are less delicate in their movements than our arms and hands, but commensurately stronger and harder to damage. This means that the lower limbs are less pliable and sensitive in their movements than the upper limbs, and so they sacrifice flexibility in the cause of greater strength.

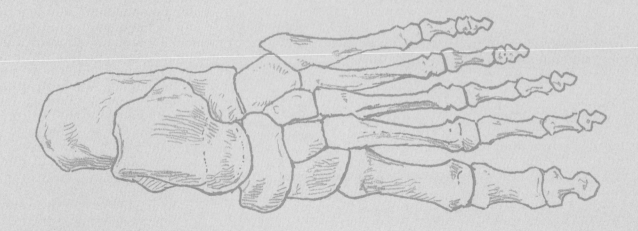

Despite the lower and upper limbs being basically similar in form, the feet are more solid and their movements less subtle than the hands, which have to perform so many more complex tasks. Nor does the knee joint have quite the same range as the elbow, or the ankle as the wrist. The toes are clearly less dexterous than the fingers, despite being constructed along similar lines, but they are also considerably stronger.

So what is most evident in the lower limbs is the power and strength, and the ability to support the whole body mass. All movements of the legs and feet are simple, but strong and distinctive.

## SKELETON OF THE LEG
### FRONT AND BACK VIEWS

The skeleton of the lower limb is composed of noticeably longer, stronger bones than the upper limb. The femur is the longest and largest bone in the human body and is

the classic shape we think of when we visualize a bone, comprising a powerful straight shaft and bulbous ends which help join it to the bone structures of the hip and knee.

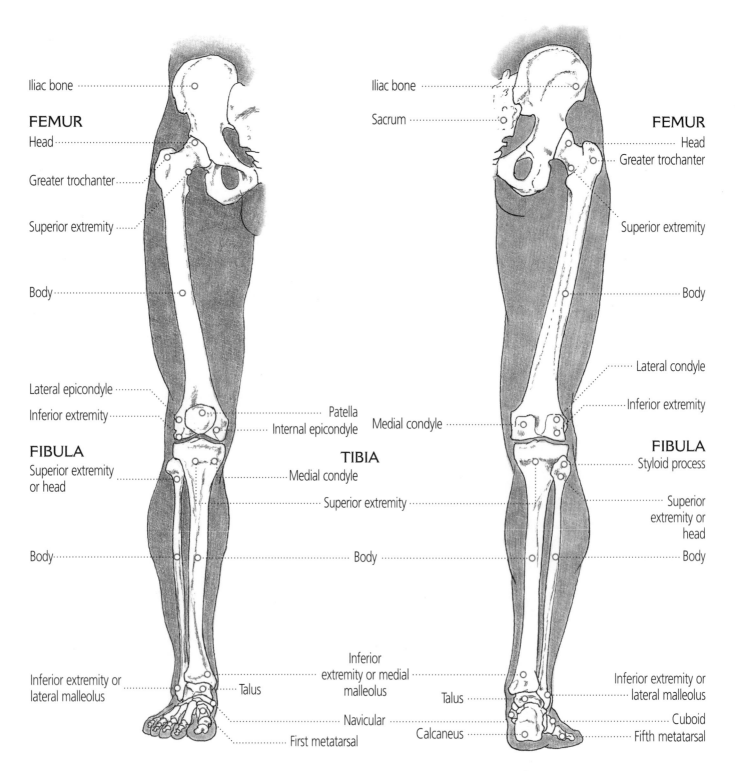

Iliac bone

**FEMUR**
Head
Greater trochanter
Superior extremity
Body

Lateral epicondyle
Inferior extremity

**FIBULA**
Superior extremity or head
Body

Inferior extremity or lateral malleolus
Talus

Patella
Internal epicondyle

**TIBIA**
Medial condyle
Superior extremity
Body

Inferior extremity or medial malleolus
Navicular
First metatarsal

Iliac bone
Sacrum

**FEMUR**
Head
Greater trochanter
Superior extremity
Body
Lateral condyle
Inferior extremity

**FIBULA**
Styloid process
Superior extremity or head
Body

Medial condyle

Talus
Calcaneus

Inferior extremity or lateral malleolus
Cuboid
Fifth metatarsal

## SKELETON OF THE LEG
### SIDE VIEW

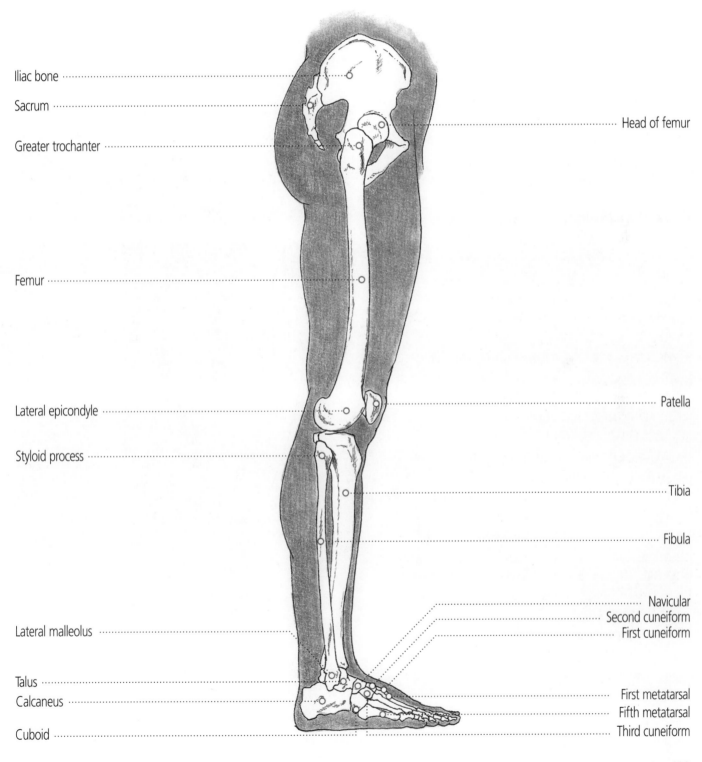

Iliac bone

Sacrum

Greater trochanter

Femur

Lateral epicondyle

Styloid process

Lateral malleolus

Talus

Calcaneus

Cuboid

Head of femur

Patella

Tibia

Fibula

Navicular

Second cuneiform

First cuneiform

First metatarsal

Fifth metatarsal

Third cuneiform

## MUSCLES OF THE HIP AND THIGH

ADDUCTOR MAGNUS, ADDUCTOR
BREVIS and ADDUCTOR LONGUS:
   simultaneous contraction of these muscles results
   in moving thigh towards centre line.
BICEPS FEMORIS flexes and then rotates leg
   towards centre line.
GEMELLUS SUPERIOR and GEMELLUS
   INFERIOR rotate thigh outwards.
GLUTEUS MAXIMUS extends from thigh onto
   fixed trunk. When leg is fixed, trunk is bent
   backwards by its contraction. It extends hip
   joint when subject climbs stairs or rises to erect
   posture after stooping.
GLUTEUS MEDIUS rotates thigh inwards and
   outwards.
GLUTEUS MINIMUS rotates thigh inwards and
   outwards.
GRACILIS flexes and rotates leg towards centre
   line.
ILIOPSOAS when trunk is fixed, flexes and
   rotates femur inwards; when leg is fixed, flexes
   trunk.
PECTINEUS moves thigh towards centre line and
   flexes it.
QUADRATUS FEMORIS rotates thigh outwards.
QUADRICEPS MUSCLES these are the
   VASTUS INTERMEDIUS/ LATERALIS/
   MEDIALIS and the RECTUS FEMORIS; they
   extend and flex the knee.
TENSOR FASCIAE LATAE stretches fascia,
   elevates and moves thigh outwards.
RECTUS FEMORIS (see quadriceps) extends
   knee joint.
SARTORIUS moves thigh away from body and
   rotates it sideways, and flexes leg at knee joint.
SEMIMEMBRANOSUS flexes and then rotates
   leg towards centre line.
SEMITENDINOSUS flexes and then rotates leg
   towards centre line.
VASTUS MUSCLES (see quadriceps) extend and
   flex the knee.

DEEP MUSCLES
FRONT VIEW:
ADDUCTOR GROUP OF MUSCLES

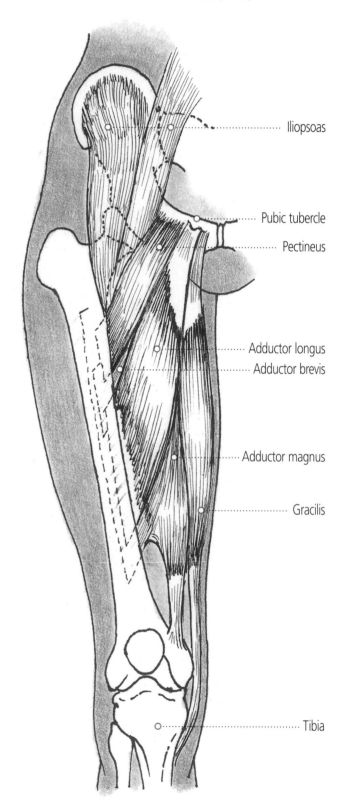

Iliopsoas

Pubic tubercle

Pectineus

Adductor longus

Adductor brevis

Adductor magnus

Gracilis

Tibia

# MUSCLES OF THE HIP AND THIGH

**MID-DEPTH MUSCLES
BACK VIEW:
ADDUCTOR GROUP OF MUSCLES**

**MID-DEPTH MUSCLES
FRONT VIEW:
QUADRICEPS MUSCLES**

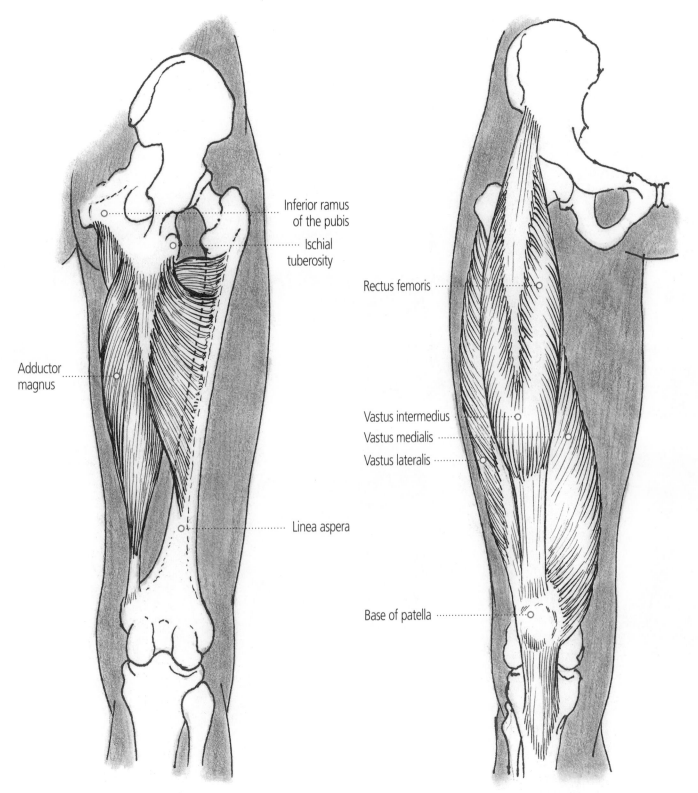

Inferior ramus
of the pubis

Ischial
tuberosity

Adductor
magnus

Linea aspera

Rectus femoris

Vastus intermedius

Vastus medialis

Vastus lateralis

Base of patella

## GLUTEAL MUSCLES

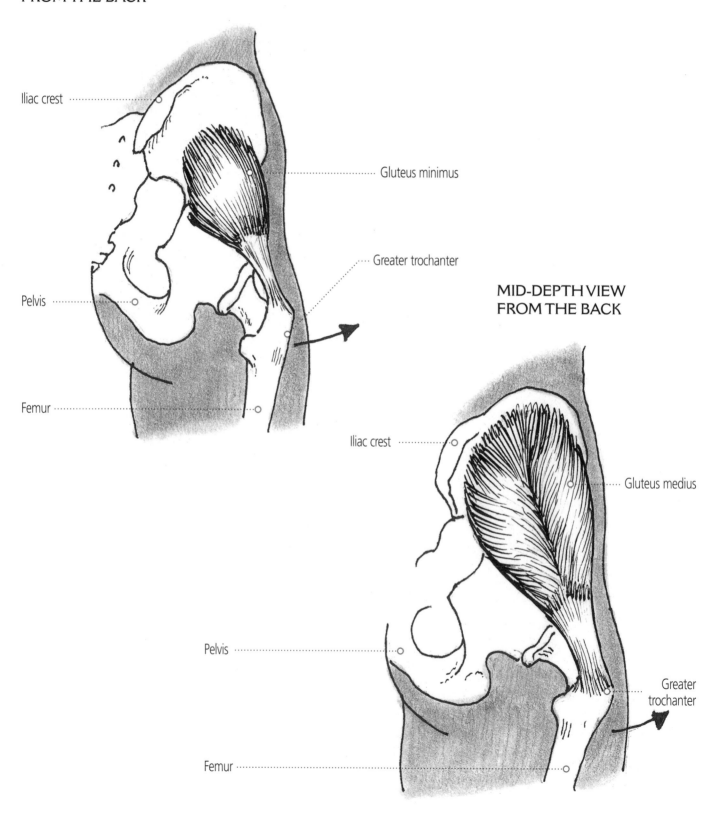

**DEEP VIEW
FROM THE BACK**

Iliac crest

Gluteus minimus

Greater trochanter

Pelvis

Femur

**MID-DEPTH VIEW
FROM THE BACK**

Iliac crest

Gluteus medius

Pelvis

Greater
trochanter

Femur

# GLUTEAL MUSCLES

**SUPERFICIAL VIEW
FROM THE BACK**

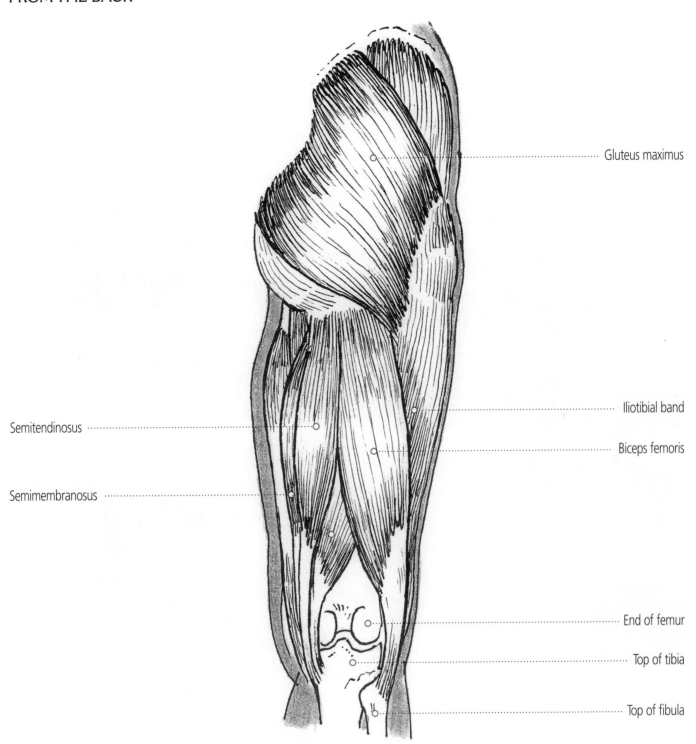

Gluteus maximus

Iliotibial band

Biceps femoris

Semitendinosus

Semimembranosus

End of femur

Top of tibia

Top of fibula

## MUSCLES OF THE THIGH

MID-DEPTH MUSCLES:
BACK VIEW

SUPERFICIAL MUSCLES:
FRONT VIEW

Semitendinosus

Biceps femoris

Semimembranosus

Iliopsoas

Inguinal ligament

Sartorius

Quadriceps

Patella

# MUSCLES OF THE THIGH

## LEG FLEXED

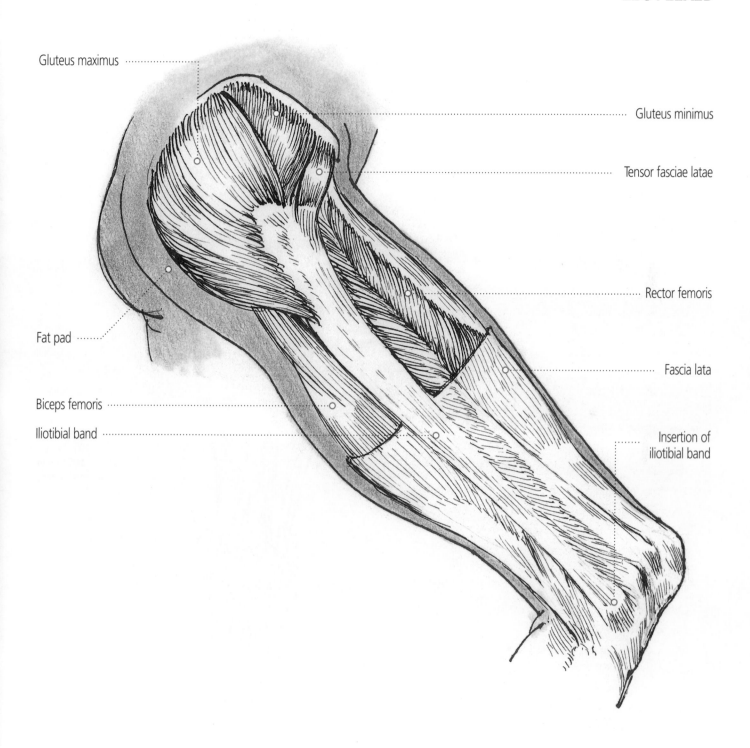

Gluteus maximus

Fat pad

Biceps femoris

Iliotibial band

Gluteus minimus

Tensor fasciae latae

Rector femoris

Fascia lata

Insertion of
iliotibial band

## MUSCLES OF THE LOWER LEG

## MUSCLES OF THE LOWER LEG AND HOW THEY WORK

FRONT VIEW

EXTENSOR DIGITORUM LONGUS straightens four lesser toes.

EXTENSOR HALLUCIS LONGUS straightens great toe.

EXTENSOR RETINACULUM, SUPERIOR AND INFERIOR enable tendons of the foot to change direction at the ankle.

FLEXOR DIGITORUM LONGUS bends second to fifth toes, helps in bending foot.

FLEXOR HALLUCIS LONGUS bends big toe (hallux) and through this the foot. Takes part in rotation of foot.

GASTROCNEMIUS extends foot downwards.

PERONEUS BREVIS raises outside edge of foot.

PERONEUS LONGUS bends and turns foot outwards, supports lateral side of arch, steadies leg on the foot, especially when standing on one leg.

PERONEUS TERTIUS raises the foot upwards and outwards.

PLANTARIS weakly flexes ankle and knee joint.

POPLITEUS bends and then rotates leg towards centre line.

SOLEUS extends foot downwards.

TIBIALIS LONGUS (ANTERIOR) straightens foot, raises foot arch.

TIBIALIS POSTERIOR straightens foot, turns foot inwards, supports foot arch.

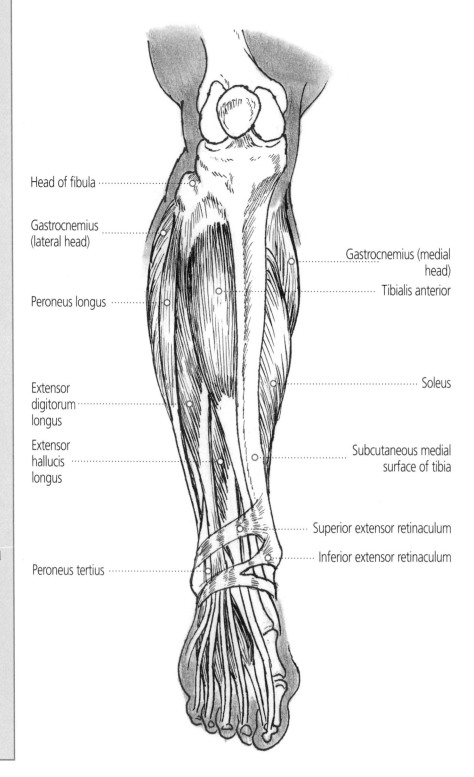

Head of fibula

Gastrocnemius (lateral head)

Peroneus longus

Extensor digitorum longus

Extensor hallucis longus

Peroneus tertius

Gastrocnemius (medial head)

Tibialis anterior

Soleus

Subcutaneous medial surface of tibia

Superior extensor retinaculum

Inferior extensor retinaculum

# MUSCLES OF THE LOWER LEG

**INSIDE VIEW**

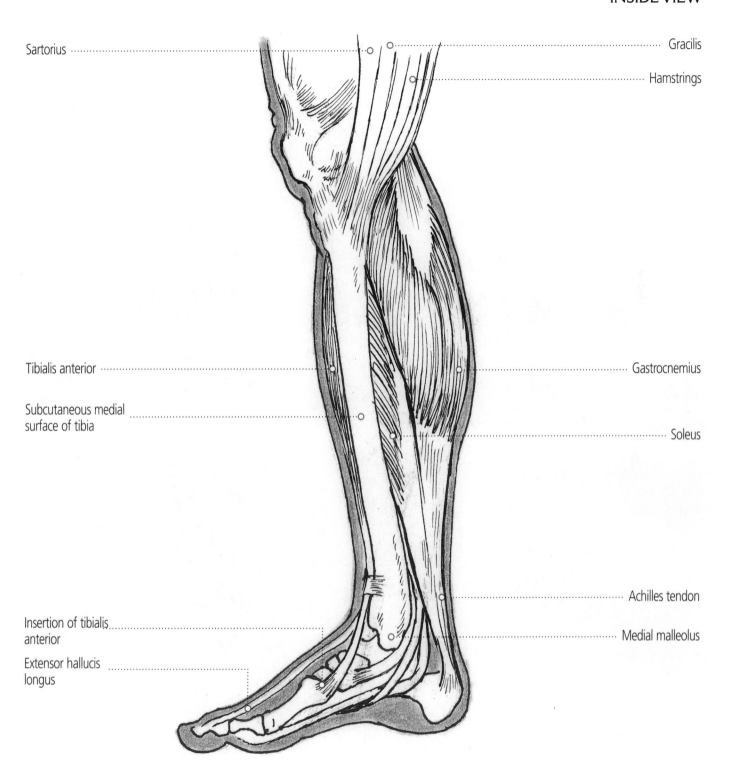

Sartorius

Gracilis

Hamstrings

Tibialis anterior

Gastrocnemius

Subcutaneous medial surface of tibia

Soleus

Achilles tendon

Insertion of tibialis anterior

Medial malleolus

Extensor hallucis longus

111

# MUSCLES OF THE LOWER LEG

**OUTSIDE VIEW:
BENDING**

**BACK VIEW:
DEEP MUSCLES**

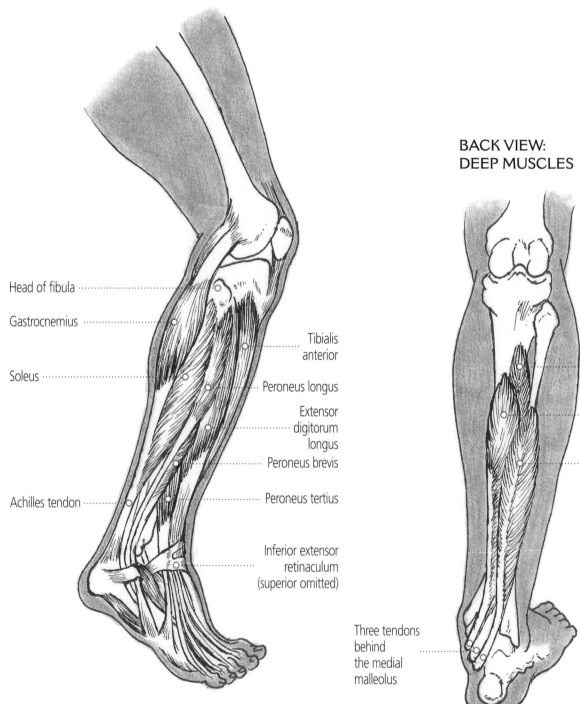
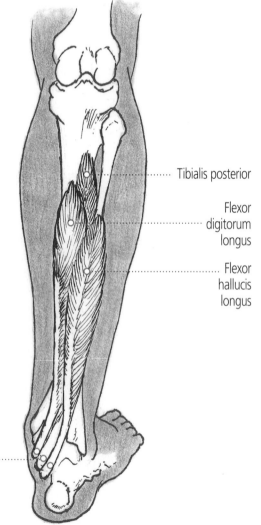

Head of fibula

Gastrocnemius

Soleus

Achilles tendon

Tibialis
anterior

Peroneus longus

Extensor
digitorum
longus

Peroneus brevis

Peroneus tertius

Inferior extensor
retinaculum
(superior omitted)

Tibialis posterior

Flexor
digitorum
longus

Flexor
hallucis
longus

Three tendons
behind
the medial
malleolus

# MUSCLES OF THE LOWER LEG

**BACK VIEW:
MID-DEPTH MUSCLES**

**BACK VIEW:
SUPERFICIAL MUSCLES**

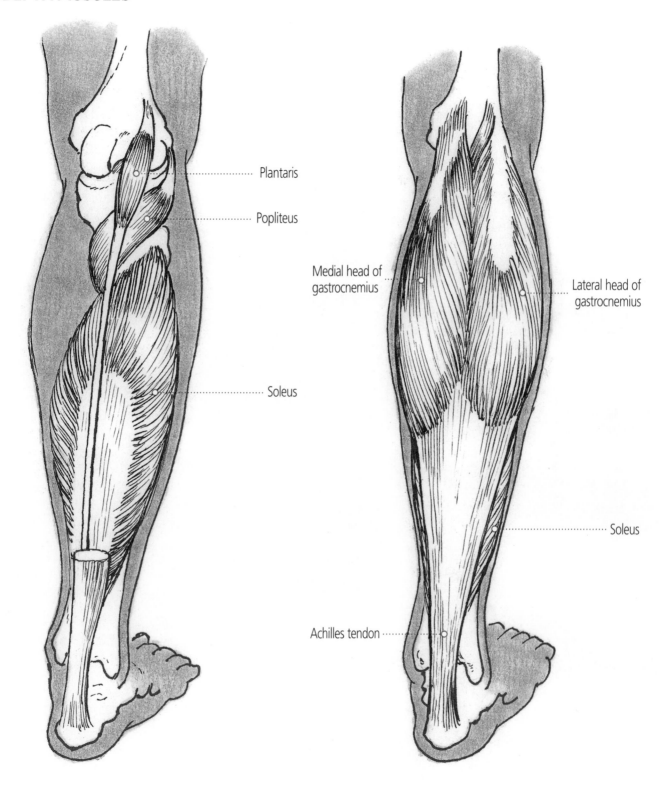

Plantaris

Popliteus

Soleus

Medial head of
gastrocnemius

Lateral head of
gastrocnemius

Soleus

Achilles tendon

## SURFACE OF THE FEMALE LEG
## FRONT AND BACK VIEW

Seeing the leg from the surface gives no real hint of its complexity underneath the skin. On the whole, the larger muscles are the only ones easily seen and the only bone structure visible is at the knee and the ankles. However the tibia (shin bone) creates a long, smooth surface at the front of the lower leg that is clearly noticeable.

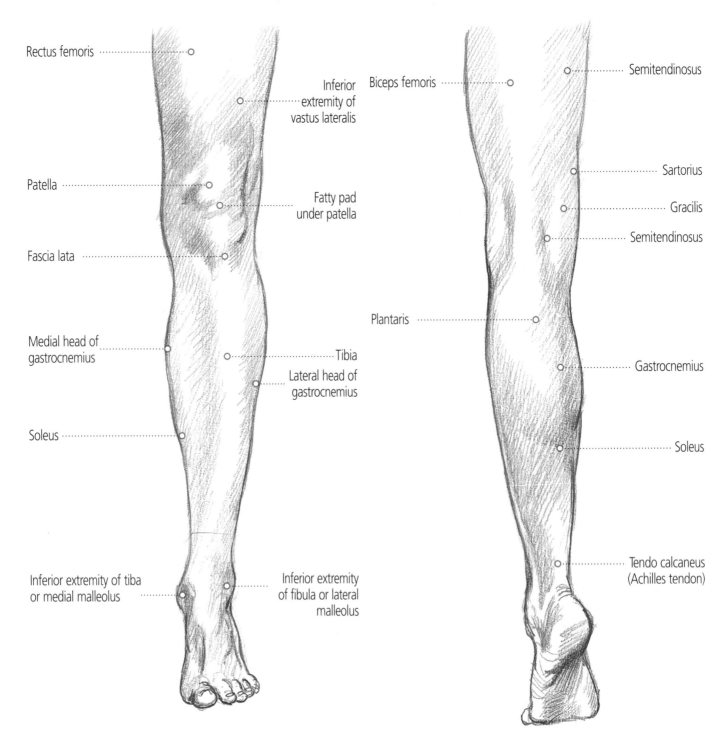

Rectus femoris

Inferior extremity of vastus lateralis

Patella

Fatty pad under patella

Fascia lata

Medial head of gastrocnemius

Tibia

Lateral head of gastrocnemius

Soleus

Inferior extremity of tiba or medial malleolus

Inferior extremity of fibula or lateral malleolus

Biceps femoris

Semitendinosus

Sartorius

Gracilis

Semitendinosus

Plantaris

Gastrocnemius

Soleus

Tendo calcaneus (Achilles tendon)

# SURFACE VIEW OF THE FEMALE LEG

The leg in movement is quite flexible, but without the more detailed movements of the arm. The emphasis is on strength and powerful movements that carry the whole body. Over the following pages are various views of legs performing simple movements: note the smoother appearance of the female limb and the clearer musculature of the male.

## SIDE VIEW: FLEXED

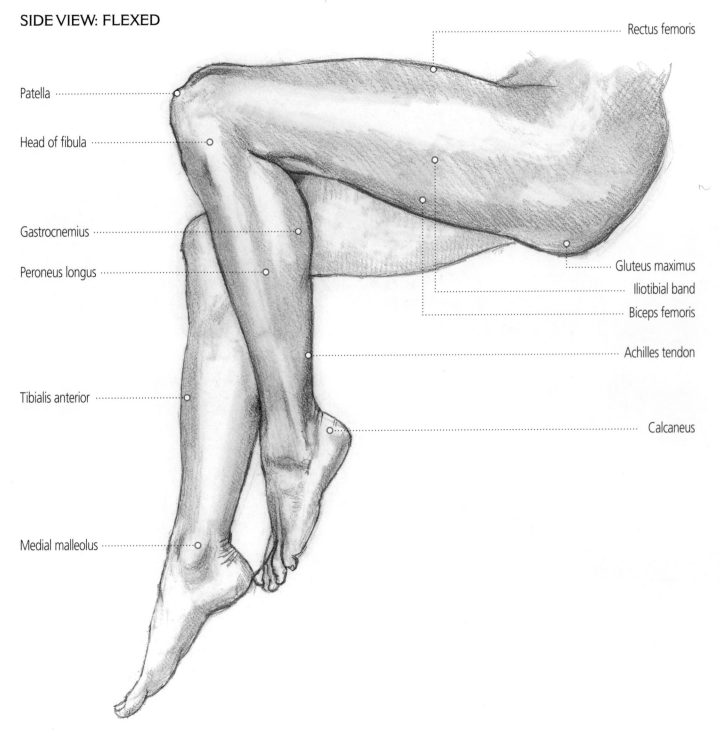

Rectus femoris

Patella

Head of fibula

Gastrocnemius

Peroneus longus

Gluteus maximus

Iliotibial band

Biceps femoris

Achilles tendon

Tibialis anterior

Calcaneus

Medial malleolus

## SURFACE OF THE MALE LEG
### FRONT AND BACK VIEWS

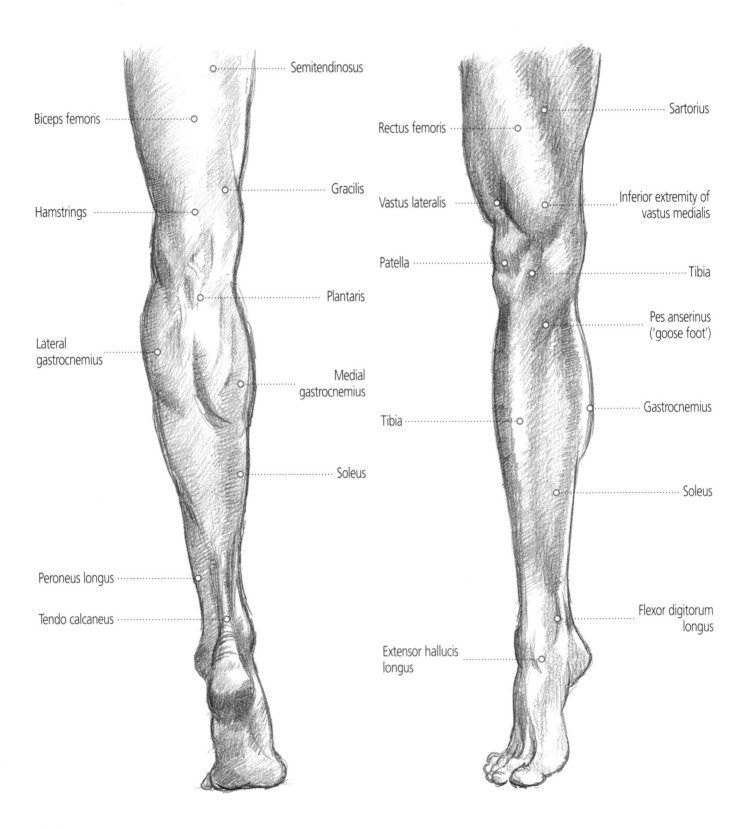

Semitendinosus

Biceps femoris

Gracilis

Hamstrings

Plantaris

Lateral gastrocnemius

Medial gastrocnemius

Soleus

Peroneus longus

Tendo calcaneus

Sartorius

Rectus femoris

Vastus lateralis

Inferior extremity of vastus medialis

Patella

Tibia

Pes anserinus ('goose foot')

Gastrocnemius

Tibia

Soleus

Flexor digitorum longus

Extensor hallucis longus

## SURFACE VIEW OF THE MALE LEG

**SIDE VIEW: FLEXED**

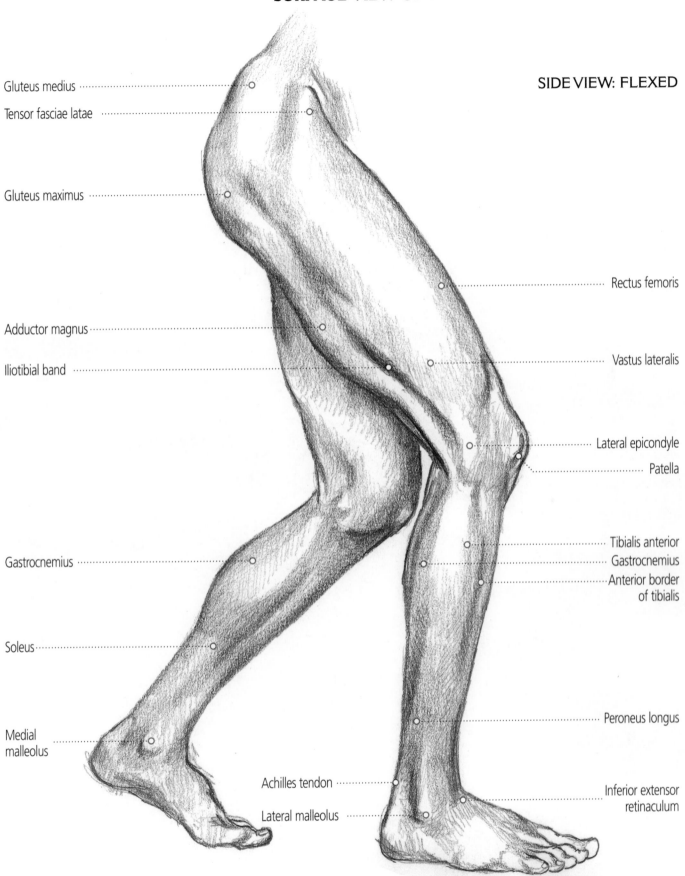

Gluteus medius

Tensor fasciae latae

Gluteus maximus

Adductor magnus

Iliotibial band

Gastrocnemius

Soleus

Medial malleolus

Achilles tendon

Lateral malleolus

Rectus femoris

Vastus lateralis

Lateral epicondyle

Patella

Tibialis anterior

Gastrocnemius

Anterior border of tibialis

Peroneus longus

Inferior extensor retinaculum

## SKELETON OF THE FOOT

As with the hand in the previous chapter, I will deal with the foot separately from the leg, as it is quite a complex feature. It is not such a familiar part of the body either, as people tend to keep their shoes on when walking about in public.

## SIDE VIEW

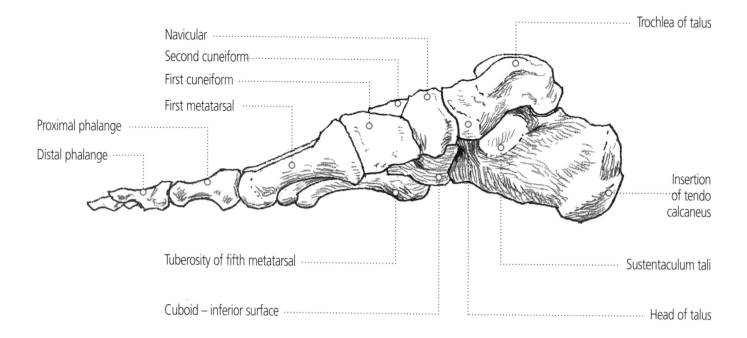

Navicular

Second cuneiform

First cuneiform

First metatarsal

Proximal phalange

Distal phalange

Trochlea of talus

Insertion of tendo calcaneus

Tuberosity of fifth metatarsal

Sustentaculum tali

Cuboid – inferior surface

Head of talus

# SKELETON OF THE FOOT

## TOP VIEW

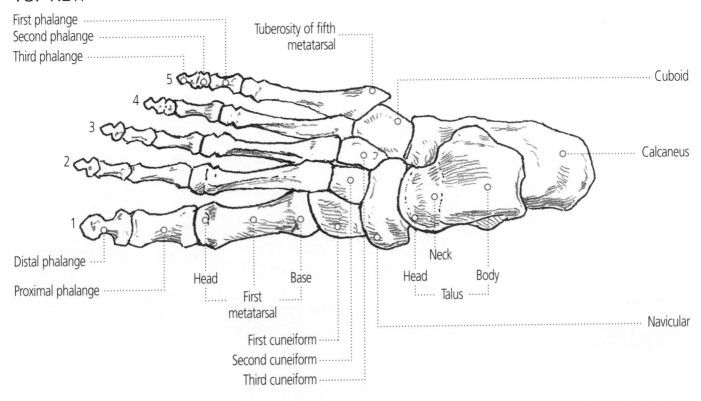

First phalange
Second phalange
Third phalange

Tuberosity of fifth metatarsal

Cuboid

Calcaneus

5
4
3
2
1

Distal phalange
Proximal phalange

Head
First metatarsal
Base

First cuneiform
Second cuneiform
Third cuneiform

Neck
Head
Talus
Body

Navicular

## BOTTOM VIEW

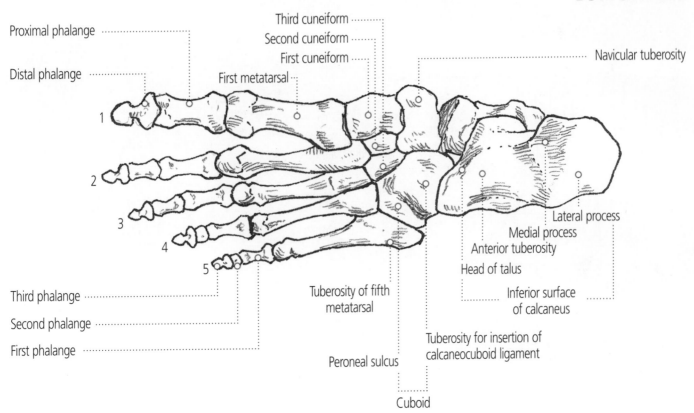

Proximal phalange
Distal phalange

Third cuneiform
Second cuneiform
First cuneiform
First metatarsal

Navicular tuberosity

1
2
3
4
5

Third phalange
Second phalange
First phalange

Tuberosity of fifth metatarsal

Peroneal sulcus

Cuboid

Tuberosity for insertion of calcaneocuboid ligament

Head of talus

Anterior tuberosity
Medial process
Lateral process

Inferior surface of calcaneus

# MUSCLES AND STRUCTURE OF THE FOOT

Like the hand, the foot is a complex structure of overlapping bone, muscle and tendons. The foot is less flexible than the hand, but stronger, and the area around the ankle and heel has much larger bones than the wrist. Most of the muscles are found underneath the bones of the foot, and the toes are mainly bone and fatty pads.

## MUSCLES OF THE FOOT AND HOW THEY WORK

ABDUCTOR HALLUCIS  moves big toe outwards.

ABDUCTOR DIGITI MINIMI  moves little toe outwards.

ADDUCTOR HALLUCIS  moves big toe inwards.

EXTENSOR DIGITORUM BREVIS  straightens toes.

EXTENSOR RETINACULUM, SUPERIOR AND INFERIOR  enable tendons of the foot to change direction at the ankle.

DORSAL INTEROSSEI  deep-seated muscles that move the toes apart.

FLEXOR DIGITI MINIMI BREVIS  flexes little toe.

FLEXOR DIGITORUM BREVIS  flexes second to fifth toes.

FLEXOR DIGITORUM LONGUS  flexes second to fifth toes.

FLEXOR HALLUCIS BREVIS  flexes big toe.

FLEXOR HALLUCIS LONGUS  flexes big toe.

LUMBRICALES  these flex the proximal phalanges. Invisible from the surface.

OPPONENS DIGITI MINIMI  pulls fifth metatarsal bone towards sole.

PLANTAR INTEROSSEI  deep muscles that move third, fourth and fifth toes towards second toe, and flex proximal phalanges.

QUADRATUS PLANTAE (FLEXOR DIGITORUM ACCESSORIUS)  helps in flexing toes.

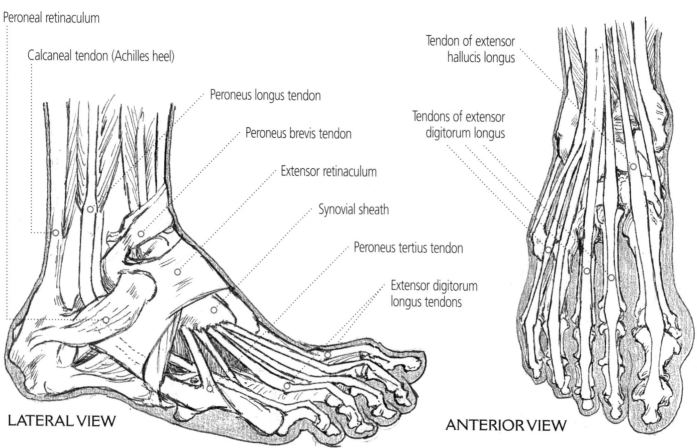

Peroneal retinaculum

Calcaneal tendon (Achilles heel)

Peroneus longus tendon

Peroneus brevis tendon

Extensor retinaculum

Synovial sheath

Peroneus tertius tendon

Extensor digitorum longus tendons

Tendon of extensor hallucis longus

Tendons of extensor digitorum longus

**LATERAL VIEW**

**ANTERIOR VIEW**

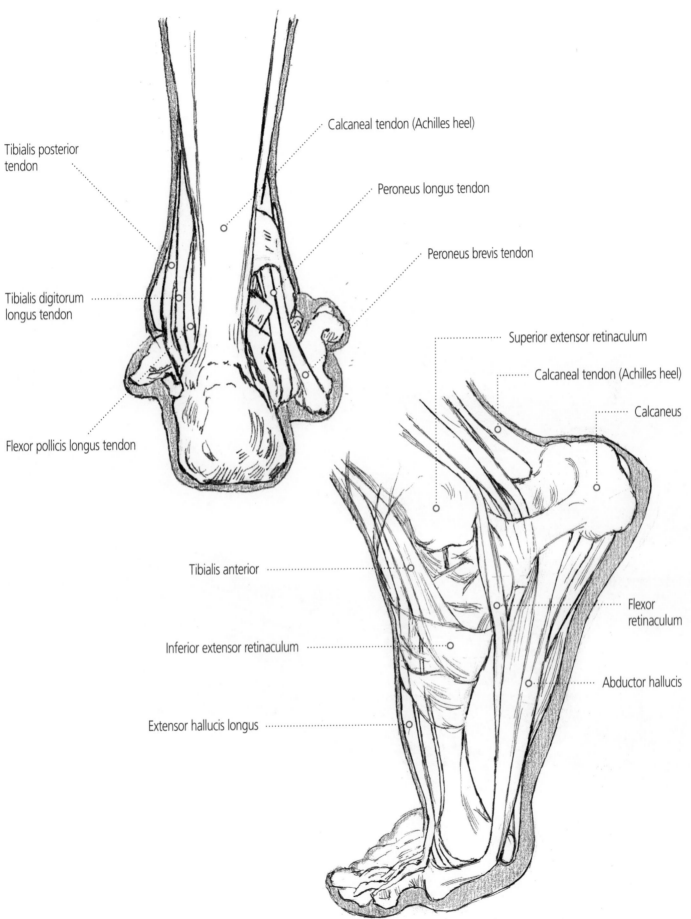

Tibialis posterior
tendon

Calcaneal tendon (Achilles heel)

Peroneus longus tendon

Peroneus brevis tendon

Tibialis digitorum
longus tendon

Flexor pollicis longus tendon

Superior extensor retinaculum

Calcaneal tendon (Achilles heel)

Calcaneus

Tibialis anterior

Flexor
retinaculum

Inferior extensor retinaculum

Abductor hallucis

Extensor hallucis longus

# MUSCLES AND STRUCTURE OF THE FOOT

**VIEWS FROM BENEATH**

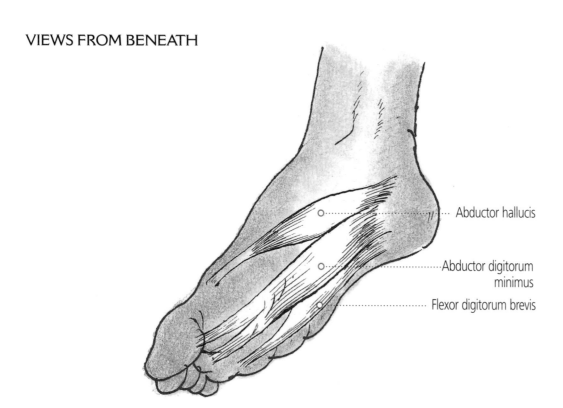

Abductor hallucis

Abductor digitorum minimus

Flexor digitorum brevis

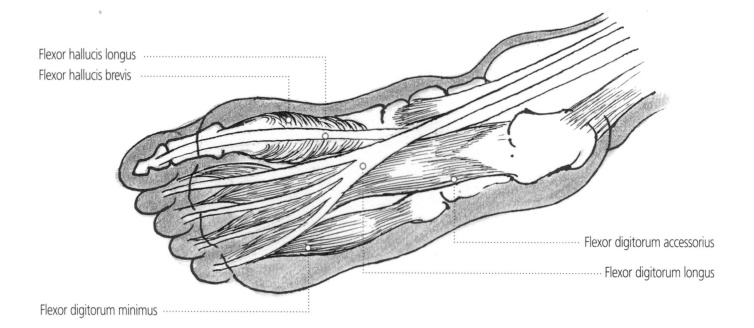

Flexor hallucis longus

Flexor hallucis brevis

Flexor digitorum accessorius

Flexor digitorum longus

Flexor digitorum minimus

## SURFACE VIEWS OF THE FOOT

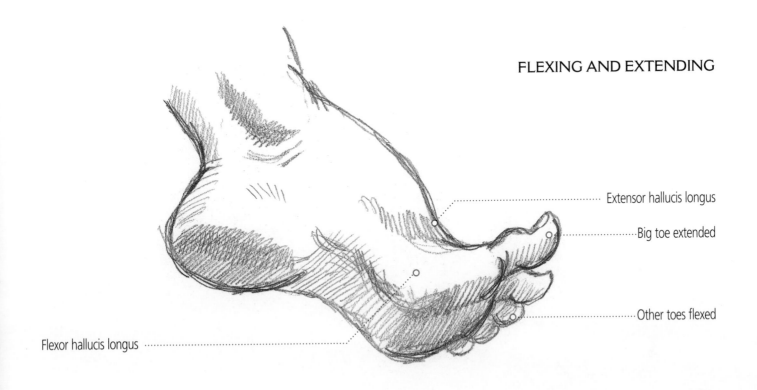

**FLEXING AND EXTENDING**

Extensor hallucis longus

Big toe extended

Other toes flexed

Flexor hallucis longus

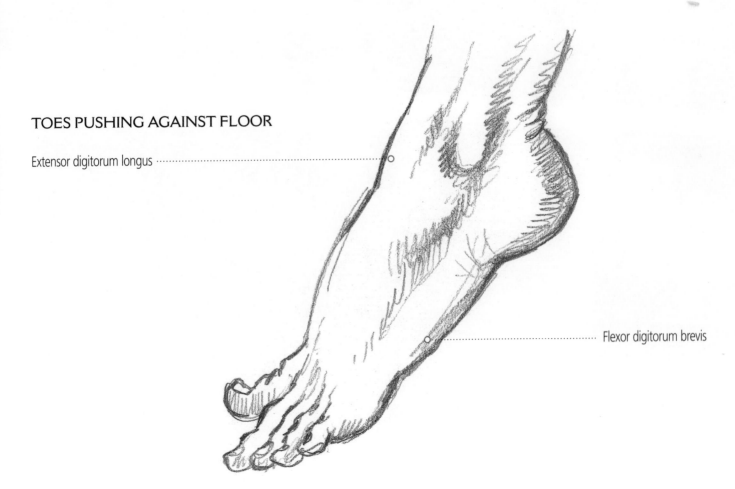

**TOES PUSHING AGAINST FLOOR**

Extensor digitorum longus

Flexor digitorum brevis

123

## SURFACE OF THE FOOT

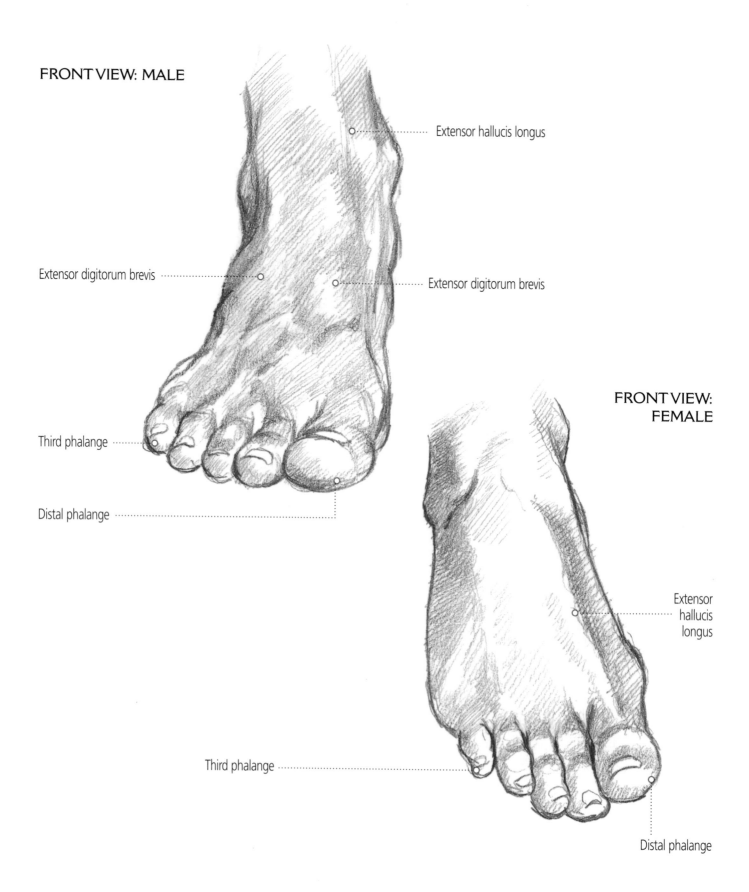

FRONT VIEW: MALE

Extensor hallucis longus

Extensor digitorum brevis

Extensor digitorum brevis

Third phalange

Distal phalange

FRONT VIEW: FEMALE

Extensor hallucis longus

Third phalange

Distal phalange

## SURFACE OF THE FOOT

**INSIDE VIEW: FEMALE**

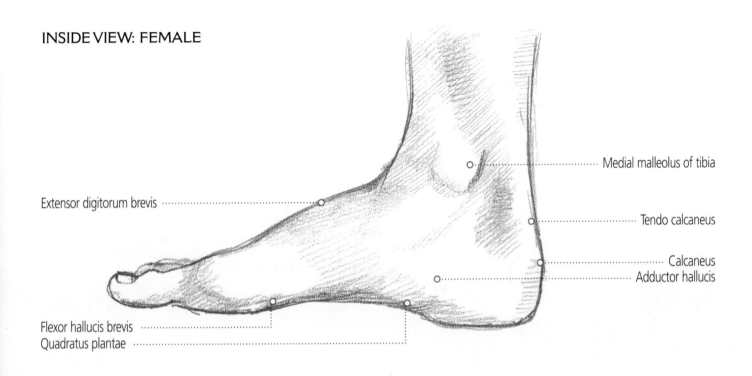

Extensor digitorum brevis ......................

Flexor hallucis brevis ......................
Quadratus plantae ......................

Medial malleolus of tibia

Tendo calcaneus

Calcaneus
Adductor hallucis

**INSIDE VIEW: MALE**

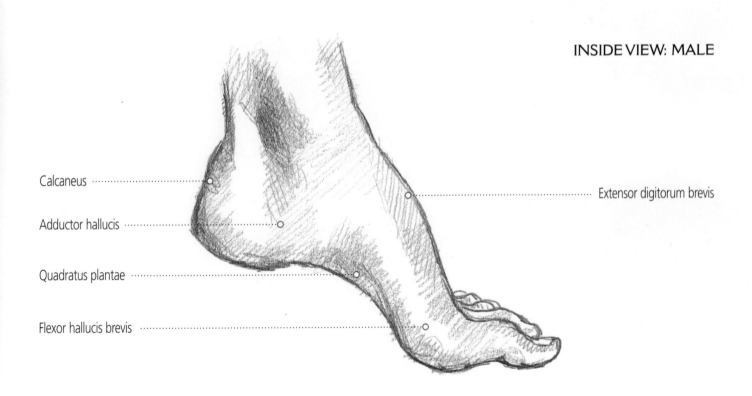

Calcaneus ......................

Adductor hallucis ......................

Quadratus plantae ......................

Flexor hallucis brevis ......................

Extensor digitorum brevis

## SURFACE OF THE FOOT

**TOP VIEW: FEMALE**

**OUTSIDE VIEW: FEMALE**

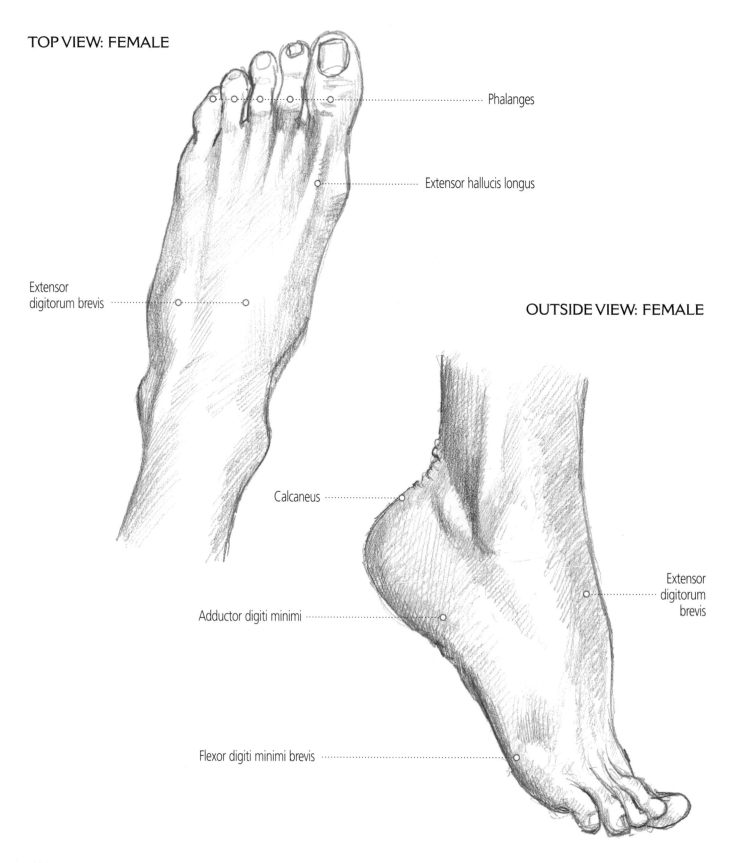

Phalanges

Extensor hallucis longus

Extensor
digitorum brevis

Calcaneus

Extensor
digitorum
brevis

Adductor digiti minimi

Flexor digiti minimi brevis

## SURFACE OF THE FOOT

**OUTSIDE VIEW: MALE**

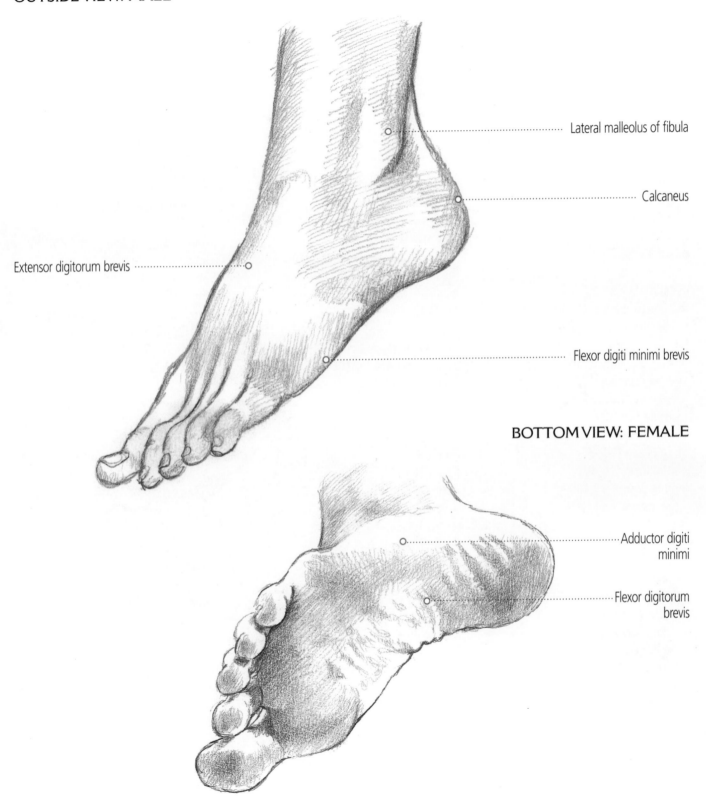

Lateral malleolus of fibula

Calcaneus

Extensor digitorum brevis

Flexor digiti minimi brevis

**BOTTOM VIEW: FEMALE**

Adductor digiti minimi

Flexor digitorum brevis